A certain kind of harmony between music and visual art exists within African American culture, and Will Downing as a vocalist and burgeoning photographer embodies a wonderfully striking yet familiar blend of these two artistic expressions. Art lovers should bear in mind that countless visual artists call on inspiration from various musical forms, especially Jazz, in order to translate sound into colorful patterns on canvas, to shape matter into three-dimensional sculptural forms, or to frame people or objects within a photographic moment. Therefore, one should be neither surprised nor confused by Downing's sensibility for capturing visually by way of photography what he experiences musically. Jazz improvisation is useful as a musical model for visual language. Just as musicians play their improvised solos as efforts to find a specific voice, so do the visual interpretations by Paul Benjamin, Kimmy Cantrell, Calvin Coleman, André Guichard, Verna Hart, Katherine Kisa, and Marcel Taylor of Downing's photographs serve as compositional "riffs," distinctive sounds with individual, creative touches.

W.E.B. Du Bois' 1903 ground-breaking book on African-American culture, *The Souls of Black Folk*, introduced the idea of the double consciousness of the African American that took the form of what he called "the veil." According to Du Bois, African Americans were veiled as they viewed life within white American society. The veil thus represented for the African American painful problems of identity, but also special advantages of perspective.

Through the *Unveiled* book series, readers and collectors gain entry into these artists' distinctive perspectives within the medium of photography and fine art. Twenty-first century art lovers who support emerging artists through ownership, especially at various stages of their development, join the world of art collecting today and for generations to come.

Nikki A Greene, PhD Candidate, Art History, University of Delaware

Unveiled

Series 1

Photography by
Will Downing
and Fine Art
By New and Emerging
African American Artists

Frist published in the United States of America by:

BroNel Enterprises Inc.
53 N. Second Street
Philadelphia, PA 19106
Phone: 215-922-4800
Fax: 215-922-7212

WD Productions Inc.
Phone: 732-873-3155
Email: wdproductions@patmedia.net
Website: www.willdowning.com

Distributed to the book trade and art trade in the United States by

BroNel Enterprises Inc.
53 N. Second Street
Philadelphia, PA 19106
Phone: 215-922-4800
email: info@artjaz.com
website: www.artjaz.com

WD Productions Inc.
Phone: 732-873-3155
Email: wdproductions@patmedia.net
Website: www.willdowning.com

Other Distribution by
ArtJaz Gallery
53 N. Second Street
Philadelphia, PA 19106
Phone: 215-922-4800
email: info@artjaz.com
website: www.artjaz.com

ISBN 0 - 9774973 - 0 - 5

Design and Pre - Press: A.Turner Design
Text Editor: R.B. Strauss

Cover Images: Photography, Angela Stribling by Will Downing, front cover art top to bottom, "My Favorite Flowers" by Paul S. Benjamin, "Under The Baobob Tree" by Kimmy Cantrell, "Roy Hargrove" by Calvin Coleman, "Once Upon a Blue Note!" by Verna Hart

Back Cover Photography, Audrey by Will Downing, back cover art top to bottom, "One With My Music" by André Guichard, "Song Bird" by Katherine Kisa, "Seductive Melodies" by Marcel Taylor, "Regina!" by Verna Hart

Printed in China, Wood Free Paper

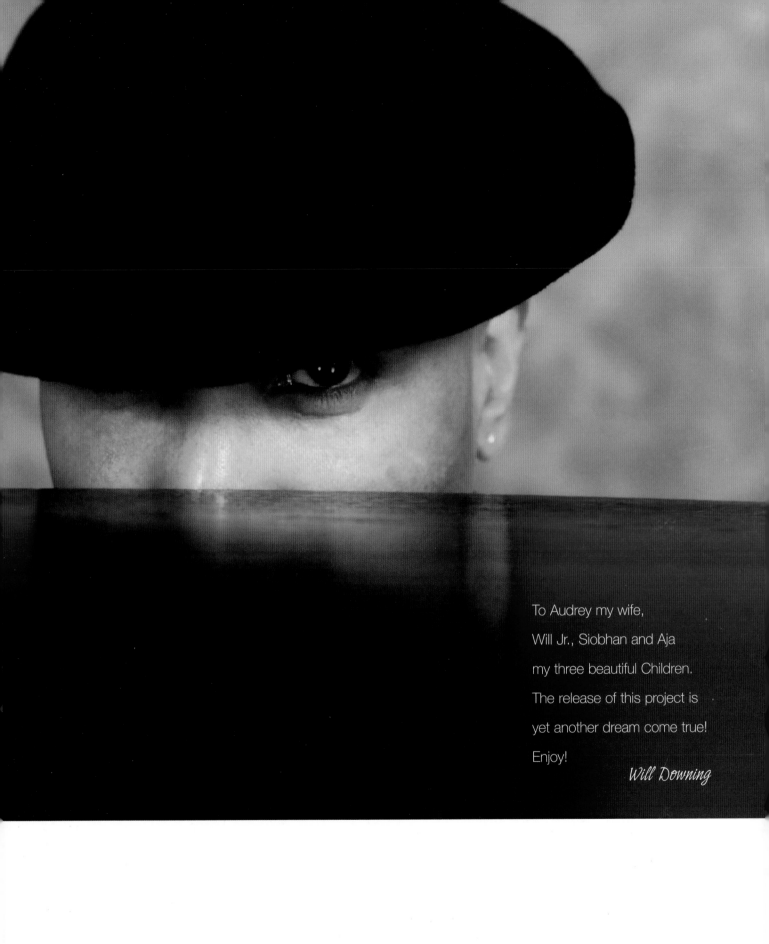

To Audrey my wife,
Will Jr., Siobhan and Aja
my three beautiful Children.
The release of this project is
yet another dream come true!
Enjoy!

Will Downing

WILL DOWNING UNVEILED

One has to reach back to bassist Milt Hinton to find another musician who worked magic with a camera as well as Will Downing does. Yet whereas Hinton was mainly a hobbyist, Downing has embarked on a concurrent career that parallels his life as a Grammy-nominated vocalist. His way with a camera follows two paths with equal skill: candid and posed pictures. Whenever he peers through his lens his goal is to capture the essence of the artist whose picture he is taking, and he does so on a level that is as intuitive as it is uncanny.

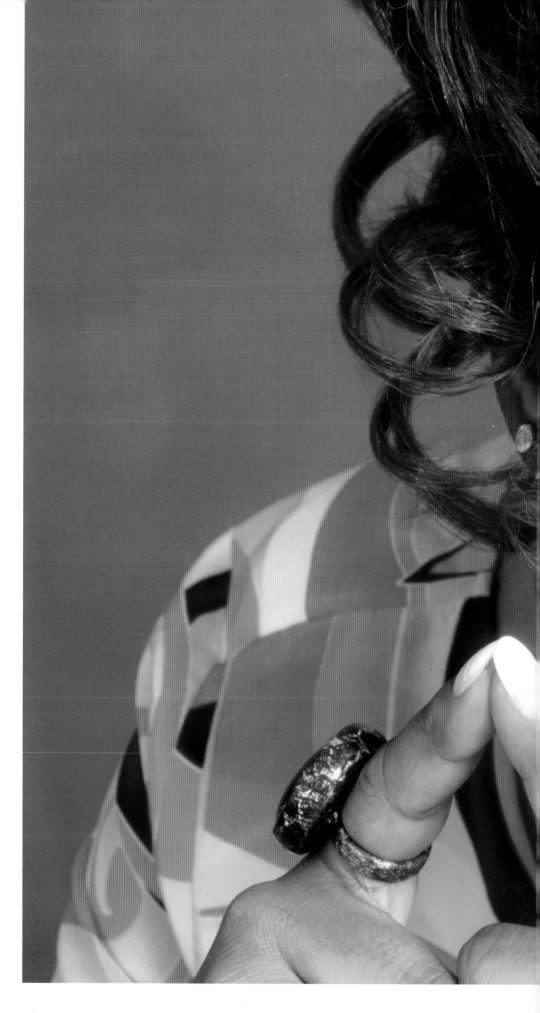

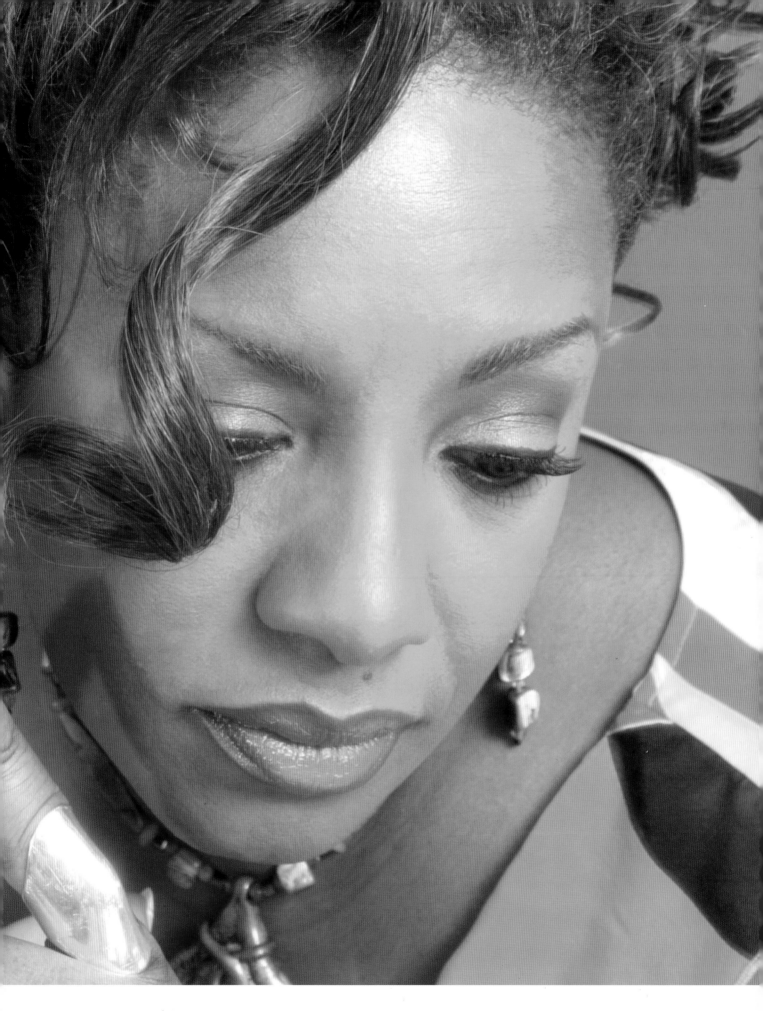

WIND

We are born by taking our first breath, and it is this initial act of life that is so well transferred by Will Downing in his portraits of horn players. Beyond the immediacy of his candid shots that capture the essence of Jazz in general and his subjects specifically, he paces these with portraits of musicians who are one with their instruments. Be it reed or brass, black and white or color photography, Will Downing acknowledges that surrendering oneself over to fingers dashing over valves in tandem with wind power is a major energy source and a conduit of the imagination.

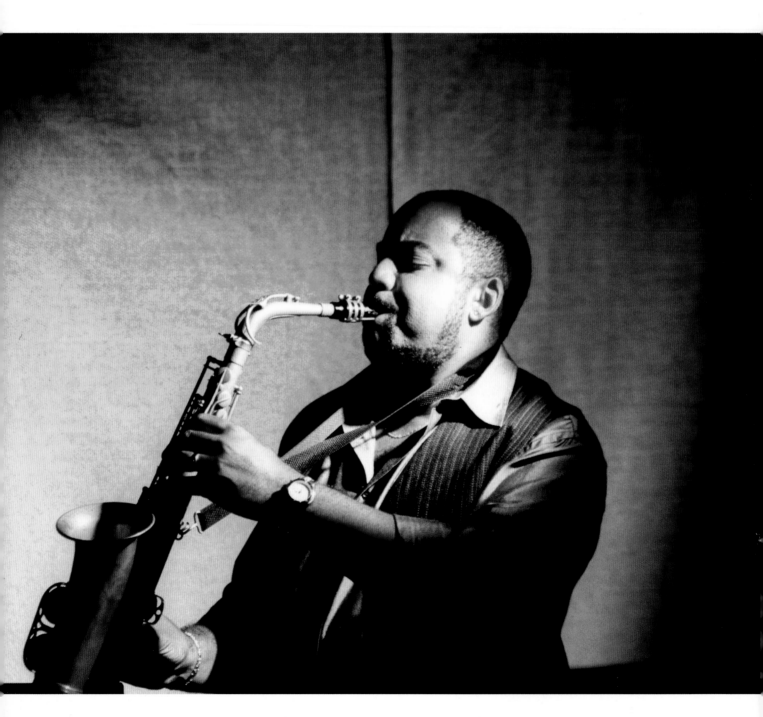

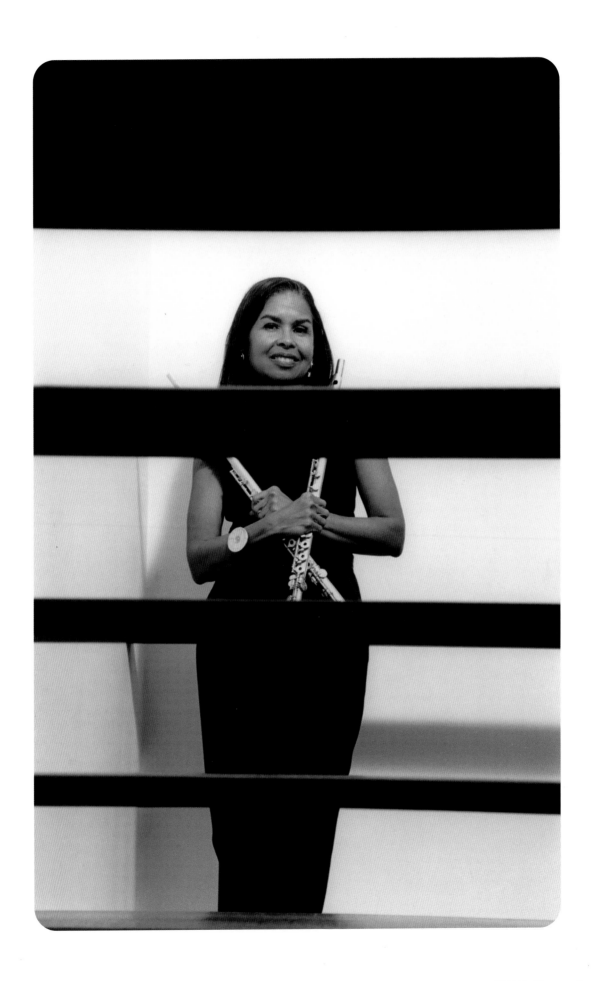

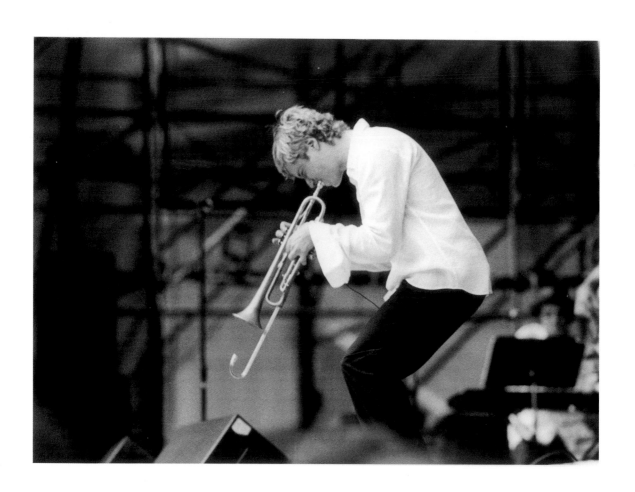

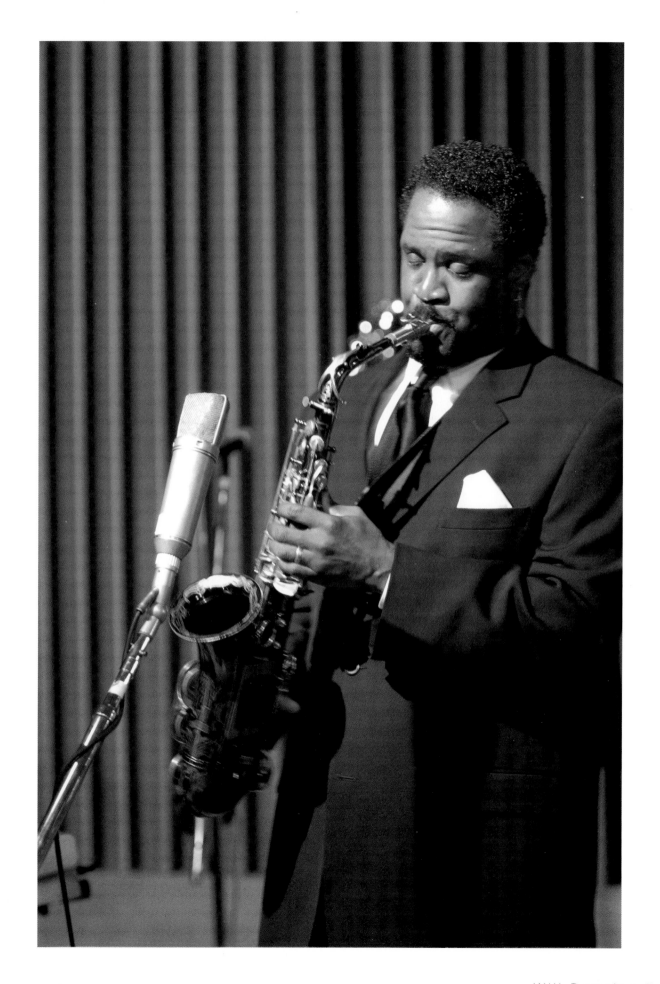

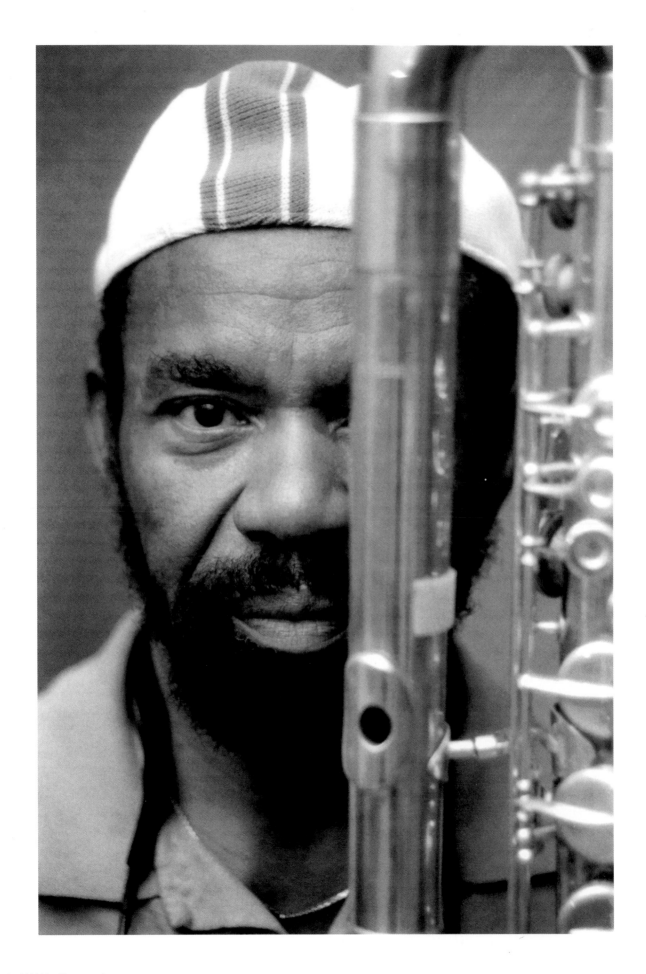

6 Will Downing

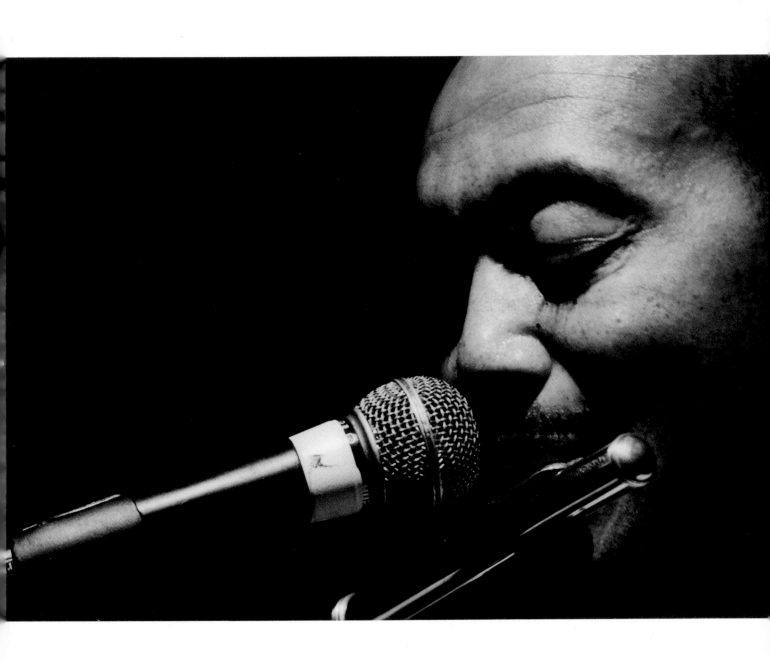

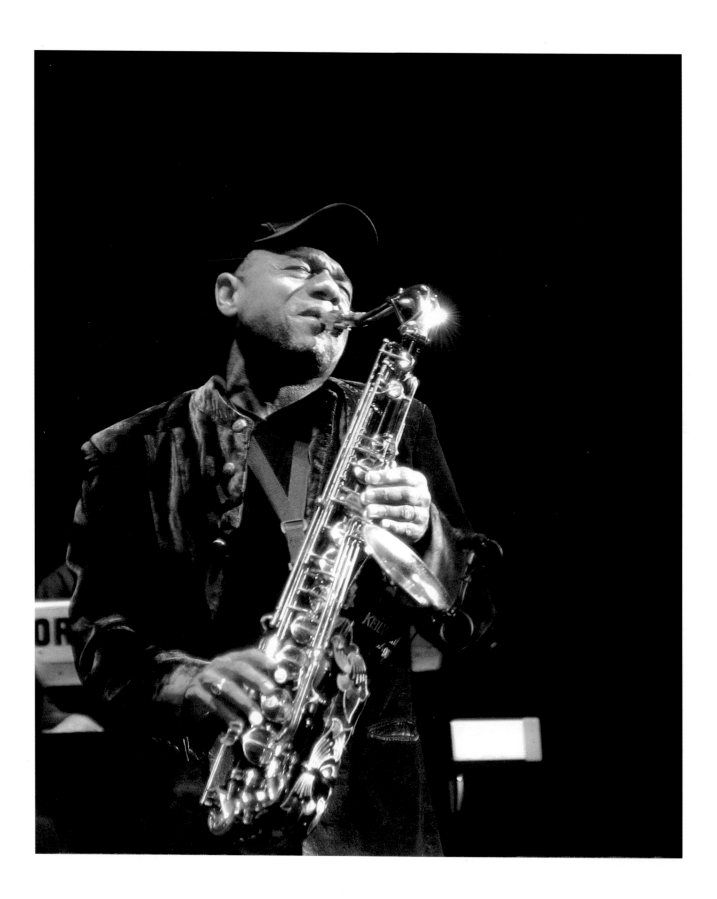

8 Will Downing

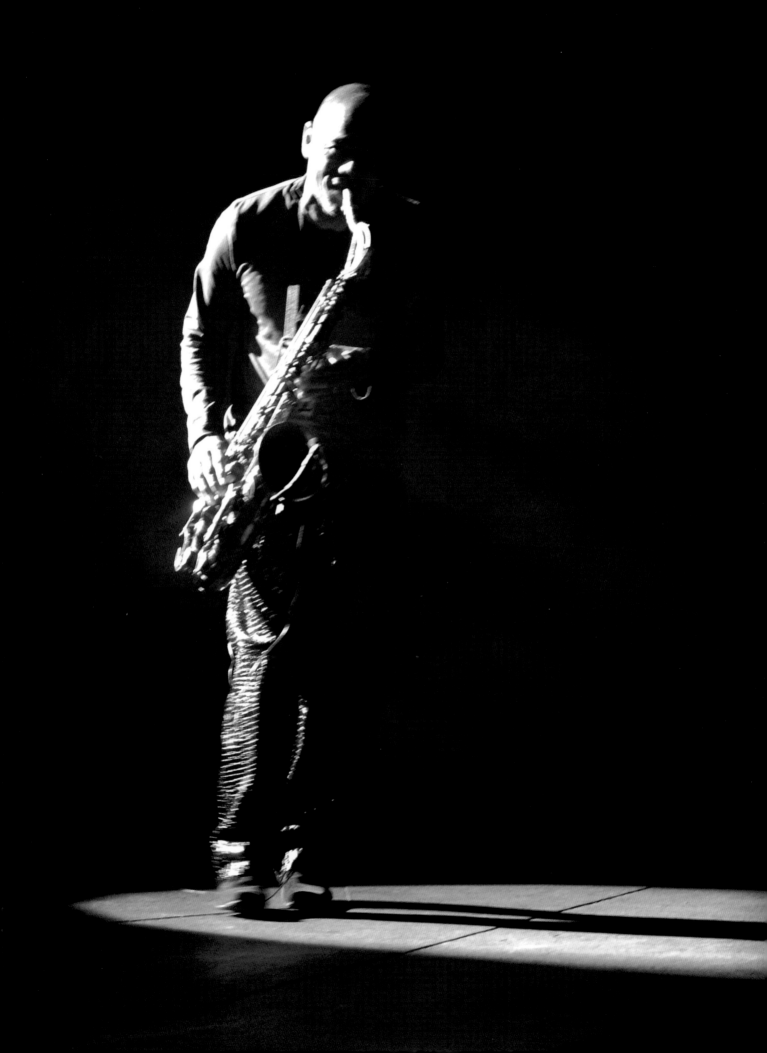

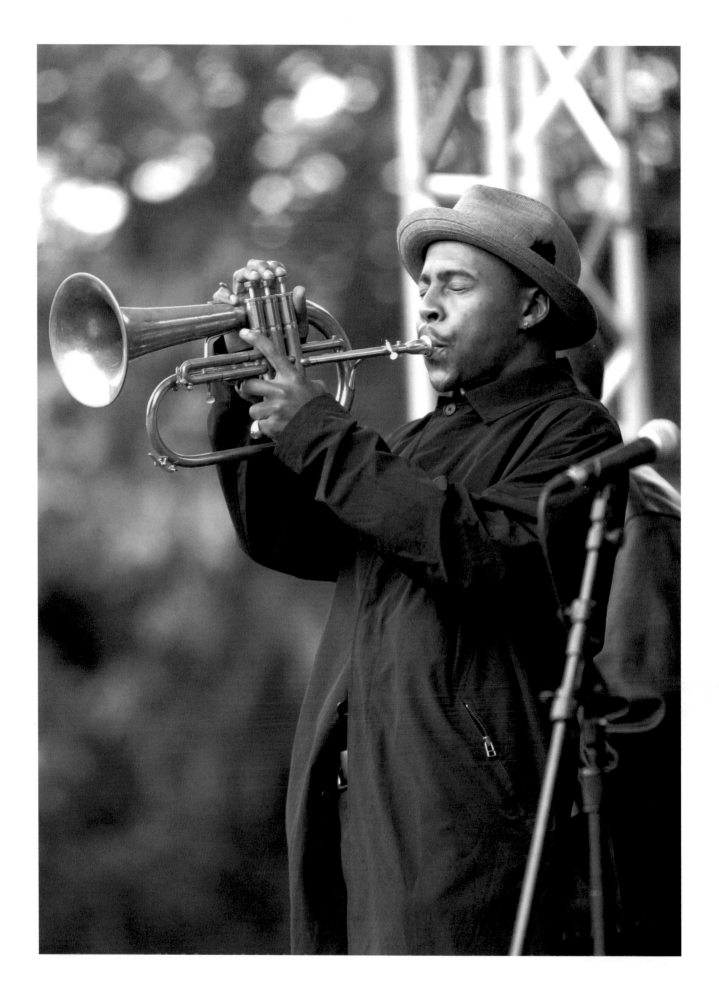

10 Will Downing

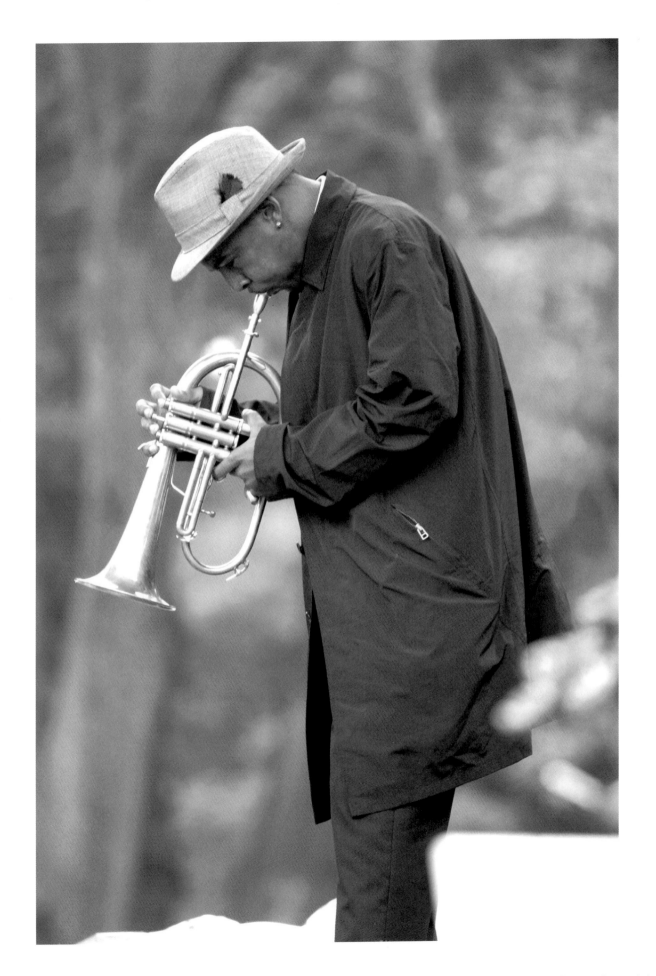

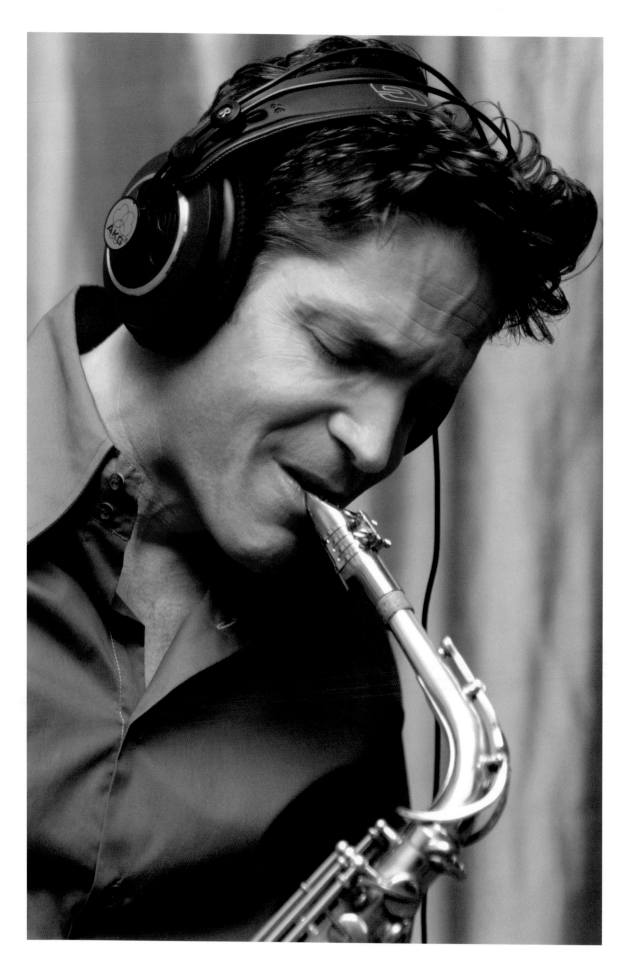

12 Will Downing

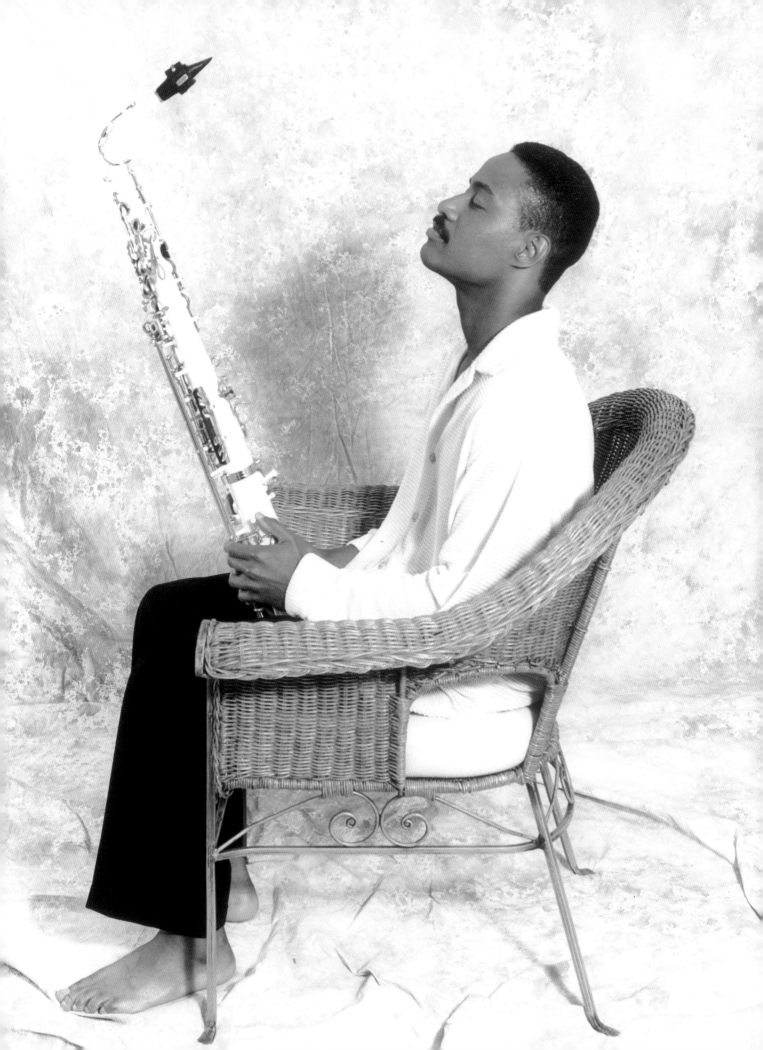

STRINGS

Like so many firsts, the first string instrument was born in Africa, and has found its way down through the eons in today's form of the kora. This long and grand lineage continues through today, and one can only wonder if the bow was first used to hurl arrows at prey or eased across strings to send music through the equatorial air. Will Downing impresses us with what he encounters with string players, and lest we not forget, the piano is as much a string instrument as anything else. The key here that Downing captures best is the hand and eye coordination of the players, all possessed of amazing dexterity as they juggle rhythm and melody and harmony with amazing chops.

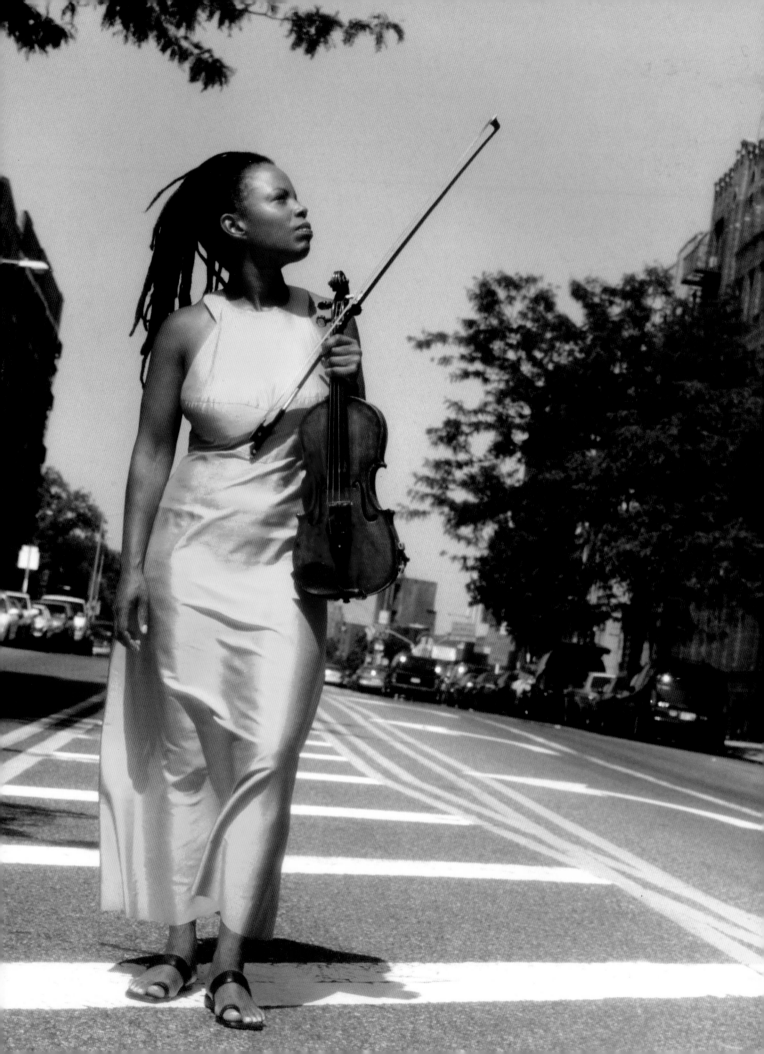

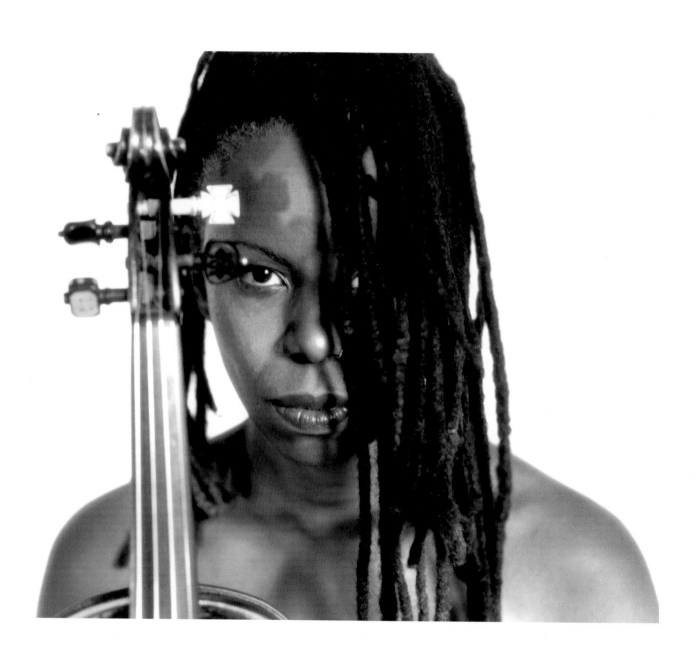

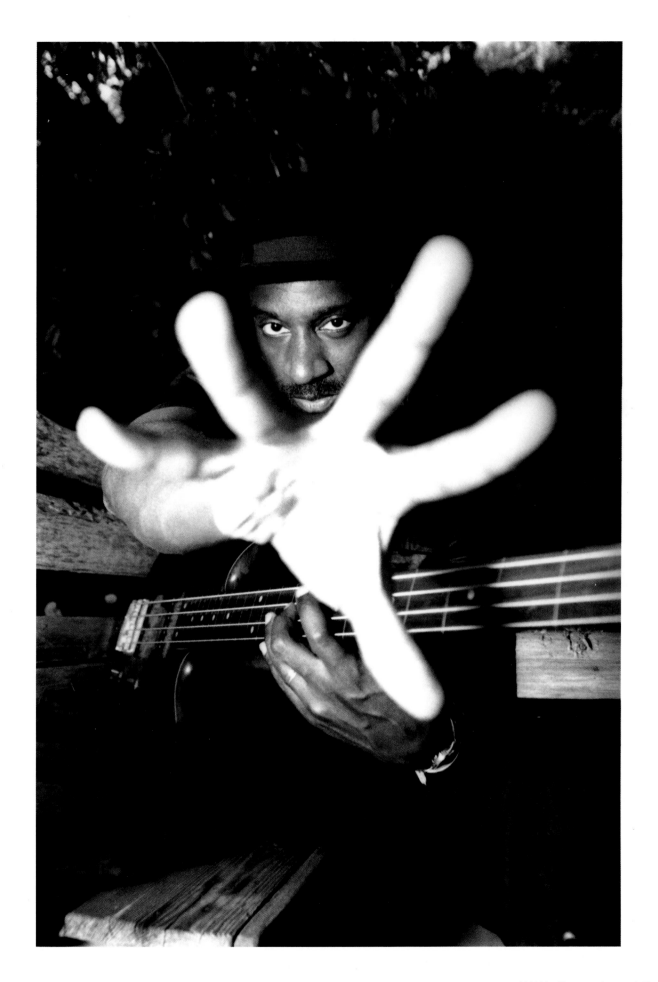

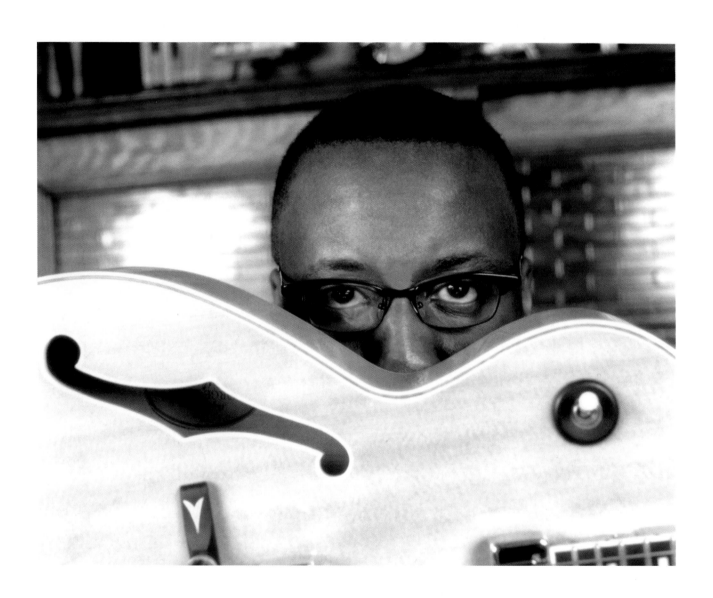

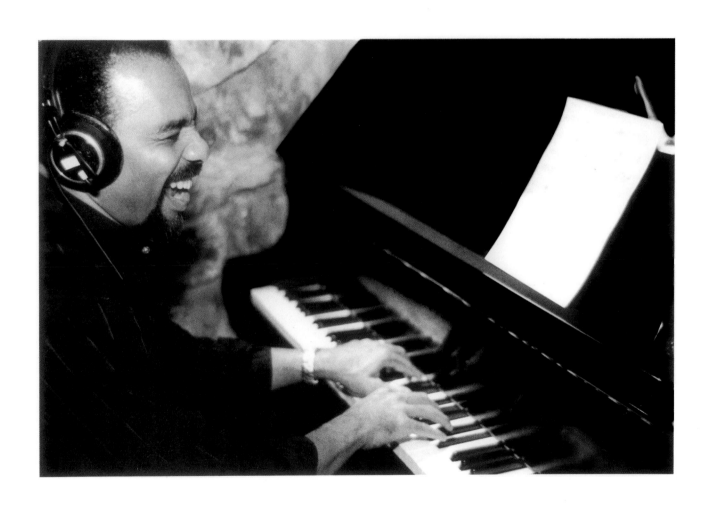

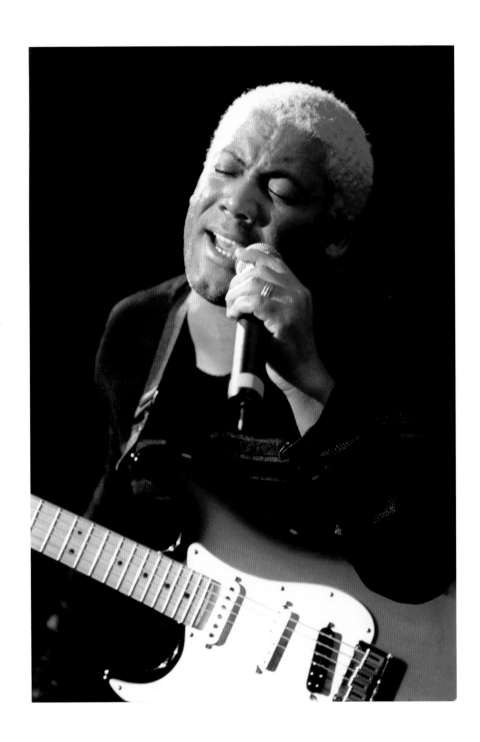

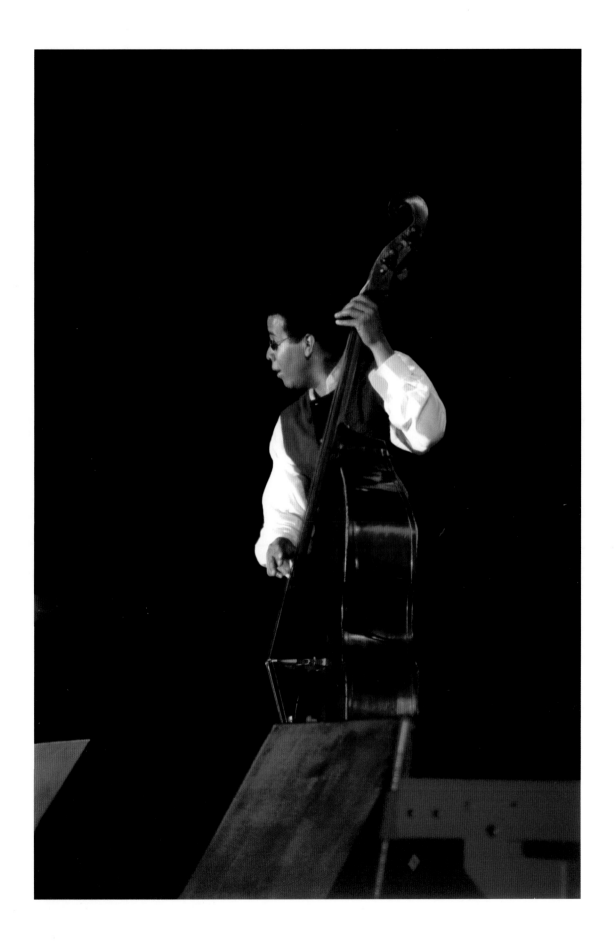

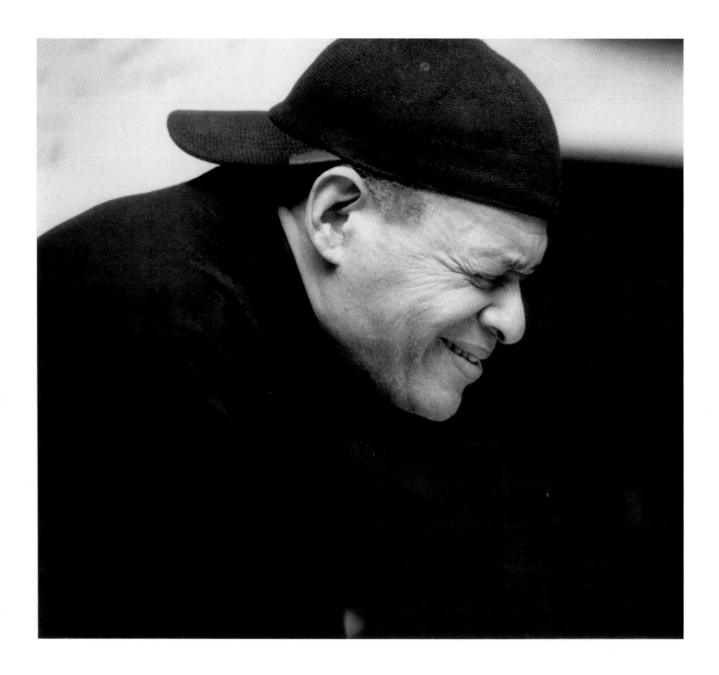

"THE VOICES"

The capacity for song is one of the great gifts of humanity, and singing has played a huge part in all of human history. Will Downing has a soft spot for vocalists, being a class act himself. And there is nothing more emotionally immediate than Jazz singers, from Louis Armstrong to Jill Scott, whom Mr. Downing relates as being right in line with Lady Day. Joy is at the center of these photographs, and there is something to each one that joins them together as family. And literal families find their place in Mr. Downing's canon as well, solidifying the basic truth that all Jazz people exemplify.

The Voice is the first instrument, and when you find someone who can really "Sang," not just Sing, well, it can be the most moving experience that you've ever heard. This is due to a number of factors, such as technique and dedication. And it is equally inviting across the musical spectrum, from Jazz to Gospel, R & B to Pop and beyond.

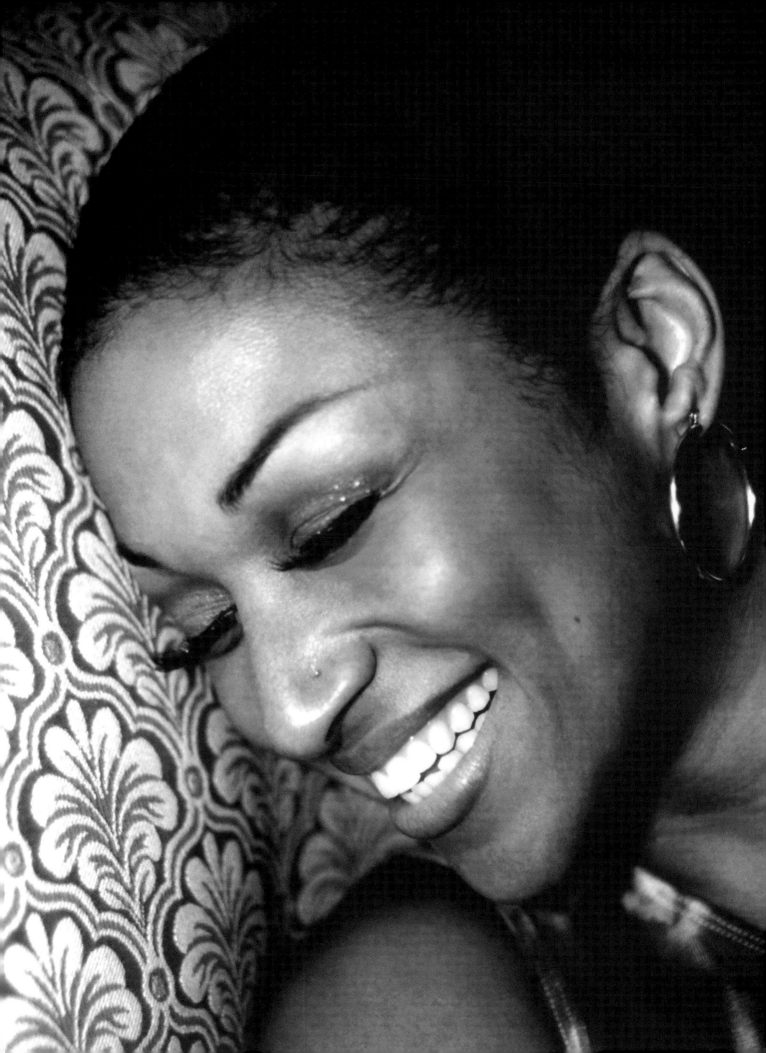

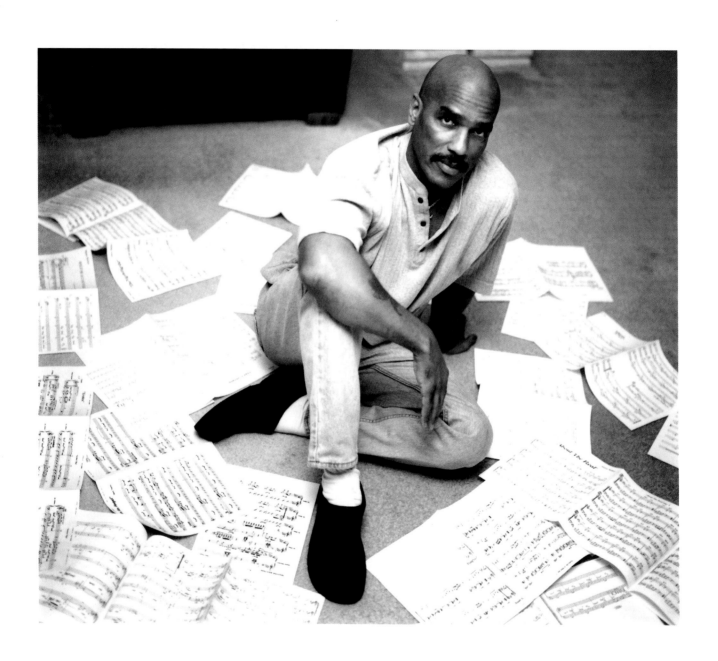

24 Will Downing

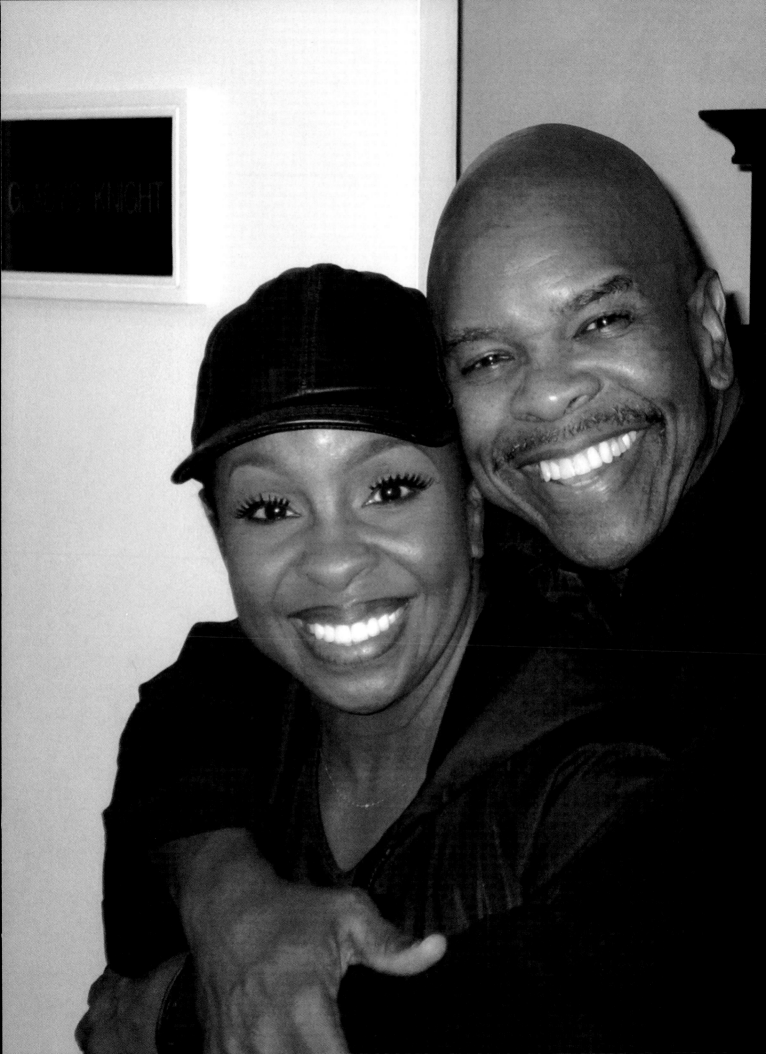

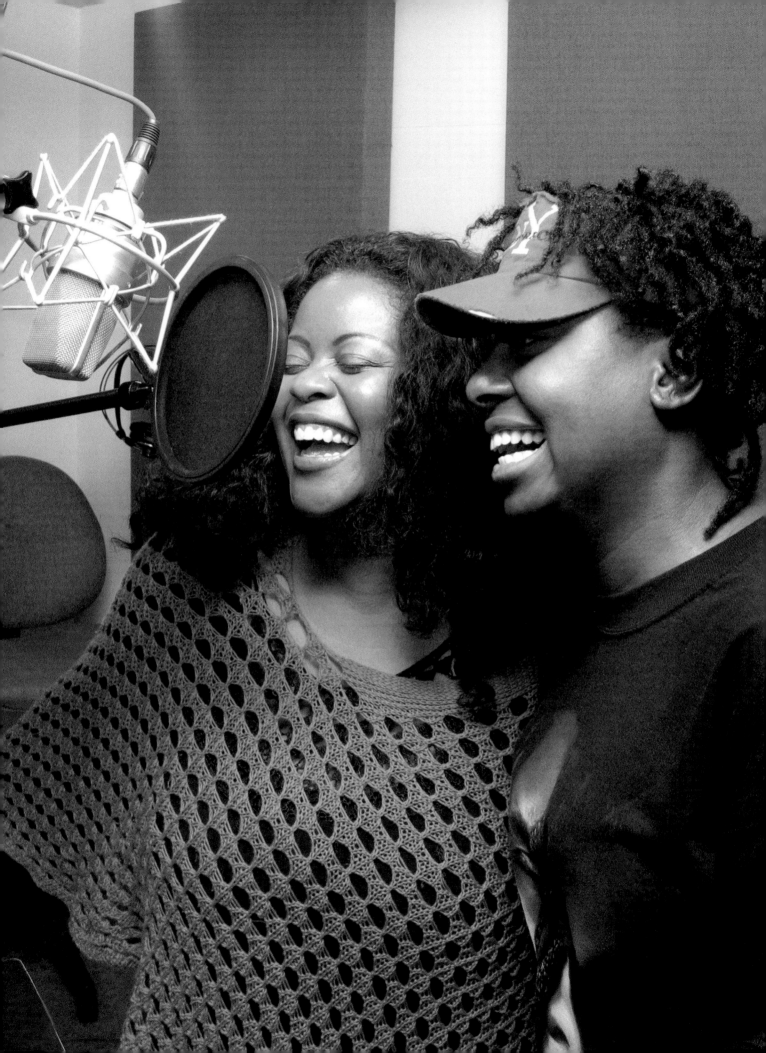

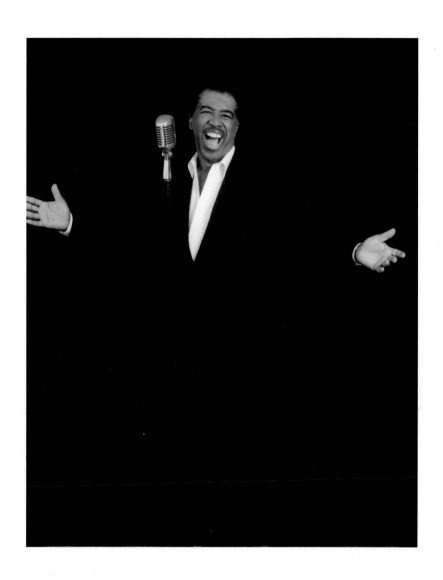

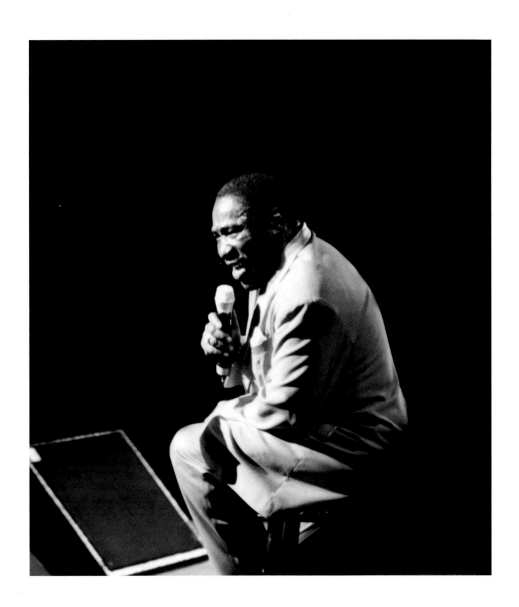

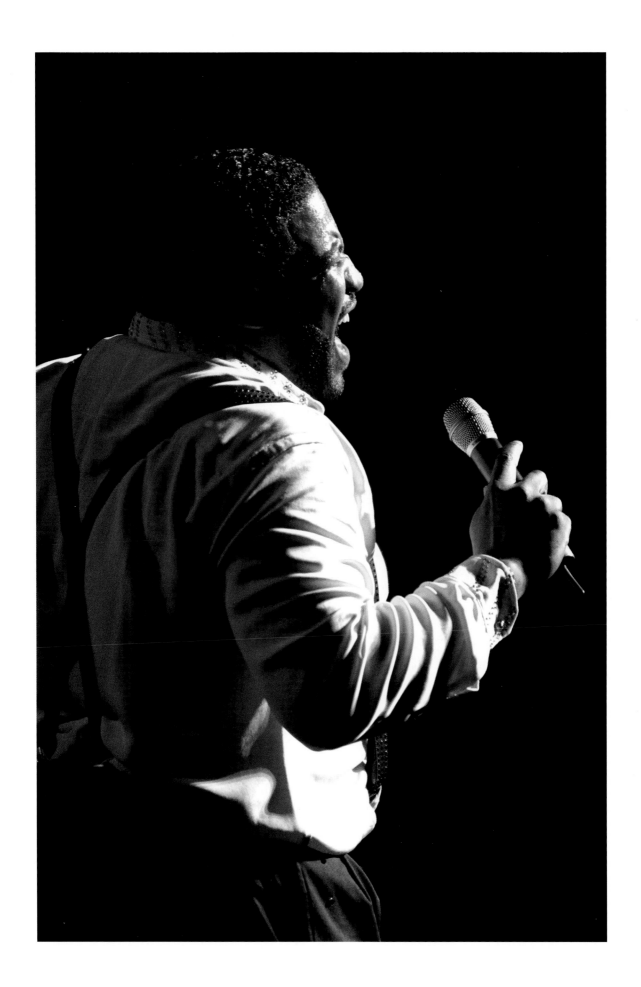

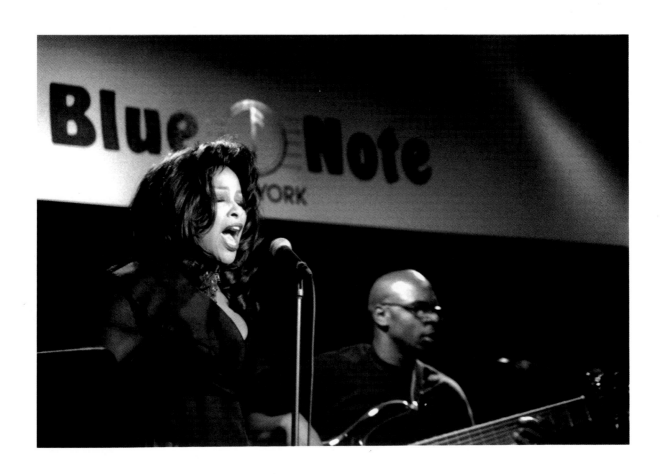

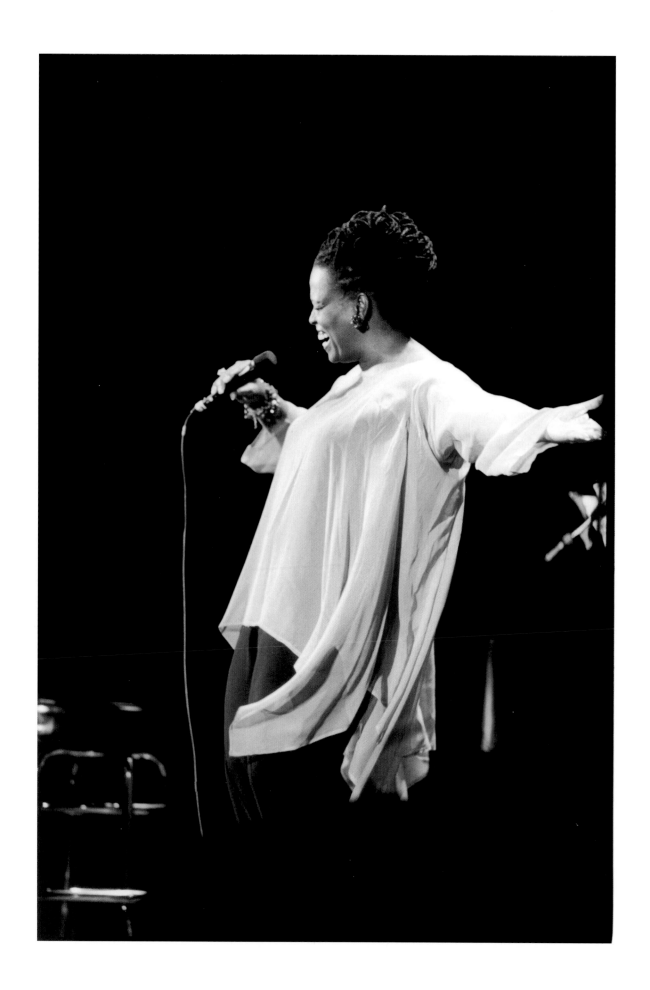

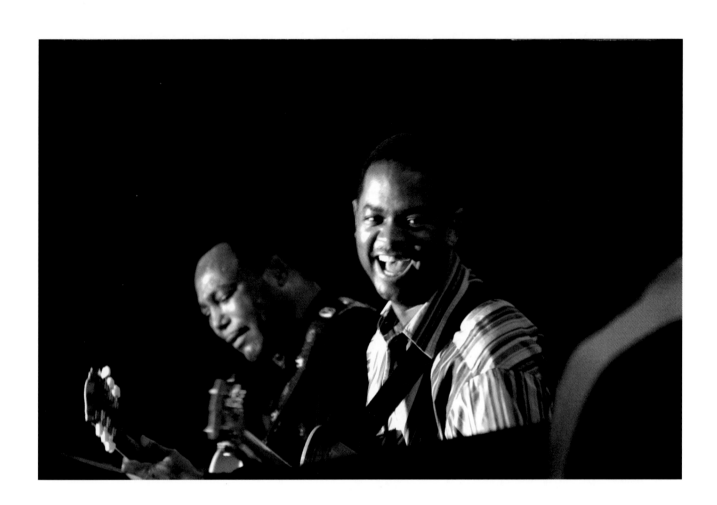

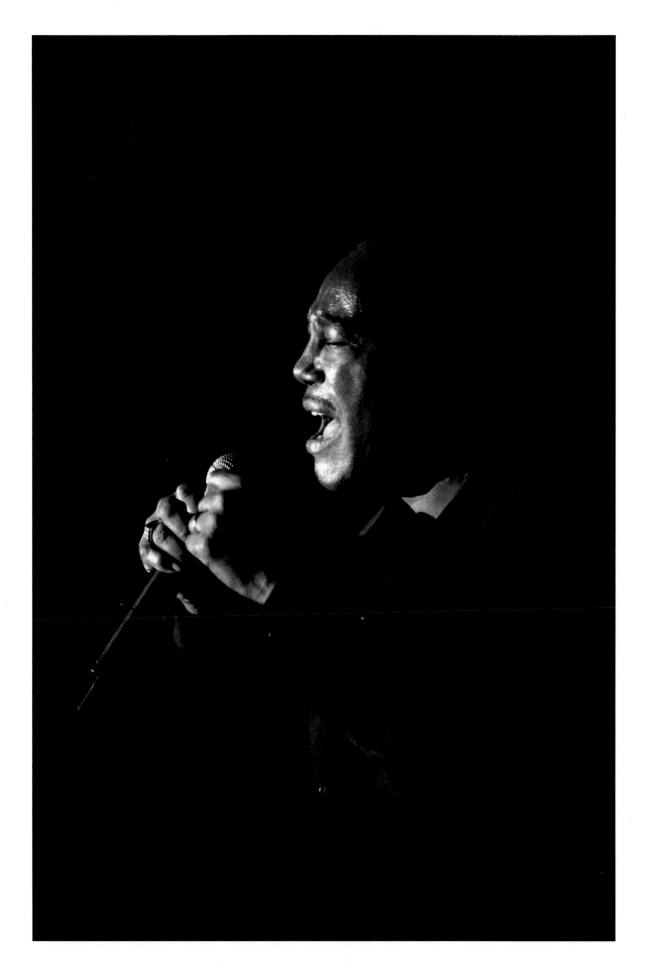

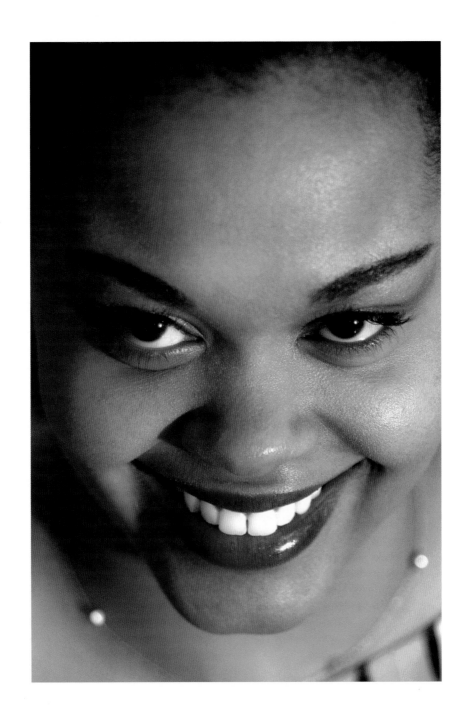

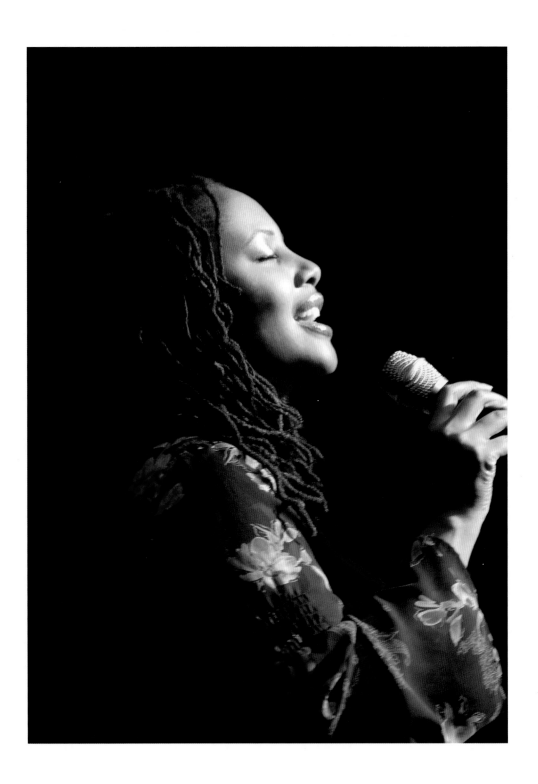

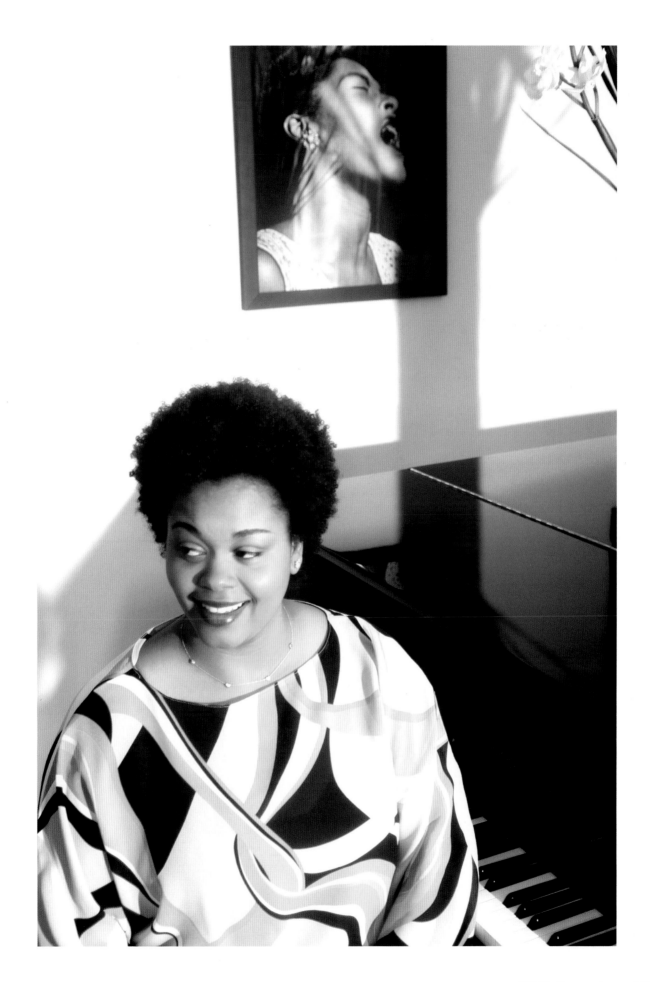

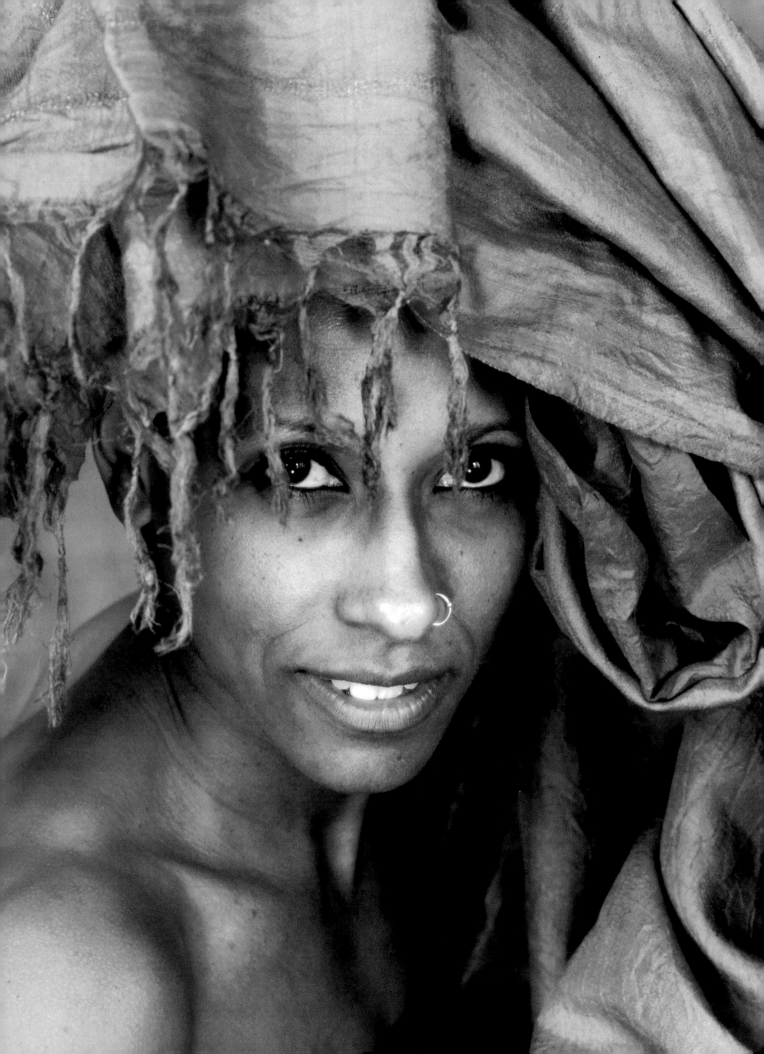

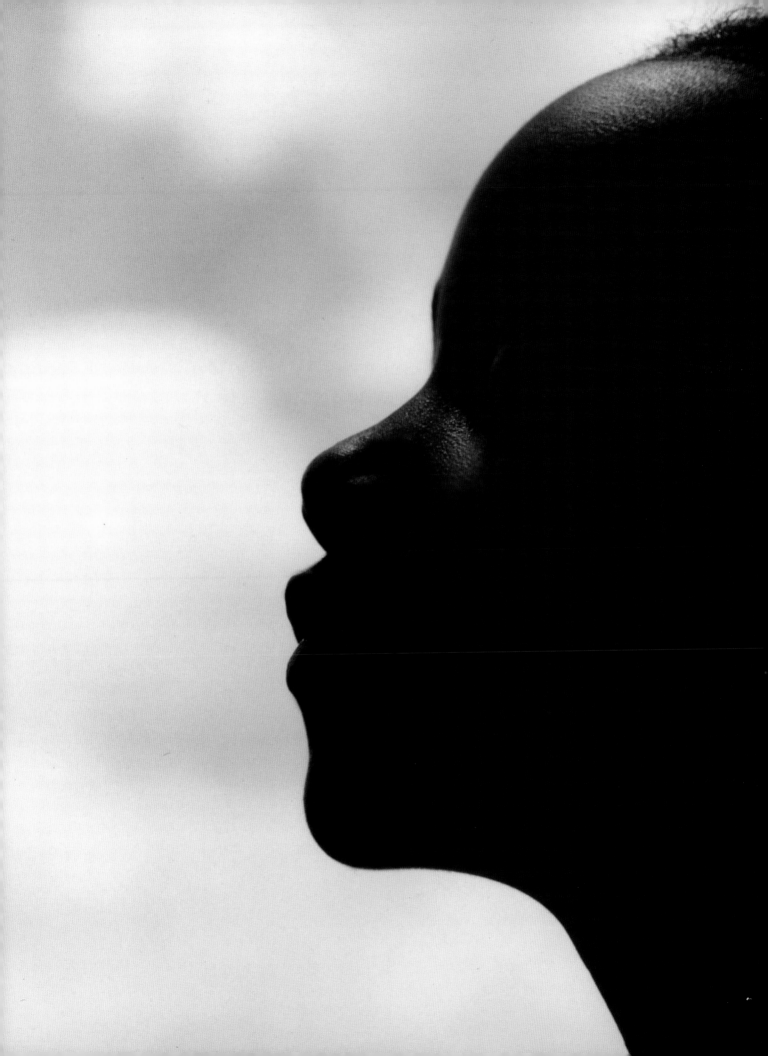

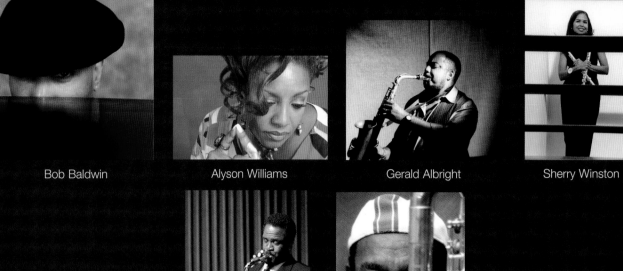

Bob Baldwin

Alyson Williams

Gerald Albright

Sherry Winston

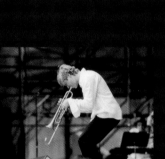

Chris Botti

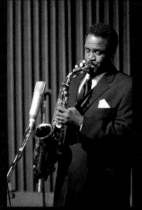

Everette Harp

Hubert Laws

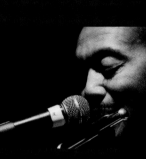

Armsted Christian

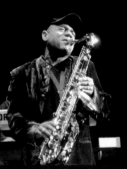

Kirk Whalum

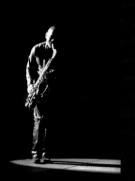

Kirk Whalum

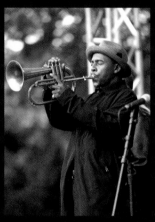

Roy Hargrove

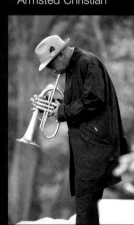

Roy Hargrove

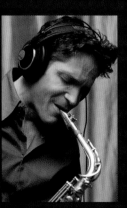

Dave Koz

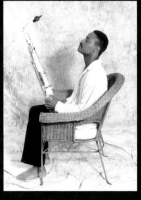

Kim Waters

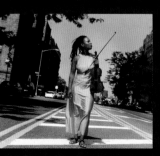

Regina Carter

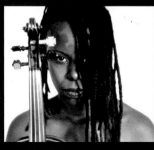

Regina Carter

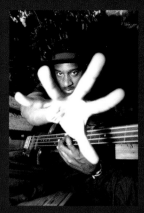

Marcus Miller

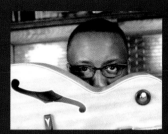

Ronnie Jordan

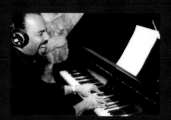

Bobby Lyle

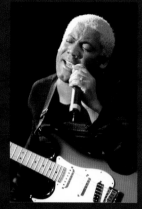

Jonathan Butler

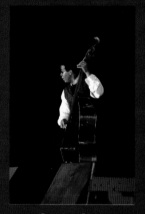

Stanley Clark

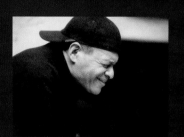

Al Jarreau

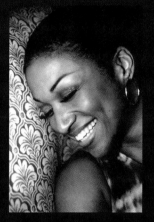

Chante Moore

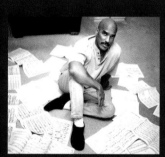

Gary Taylor

Gladys & Bubba

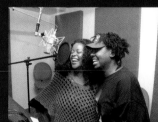

Ledesi & Maysa

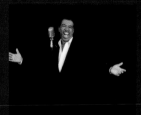

Ben E. King

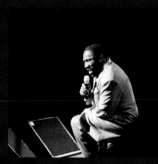

Eddie Levert

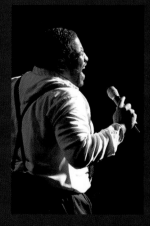

Gerald Levert

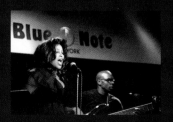

Chaka Khan

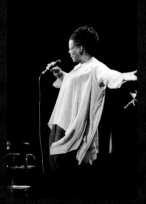

Diane Reeves

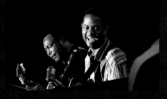

Earl Klugh & George Benson

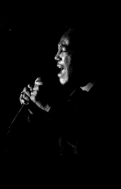
George Benson

Jill Scott

Terry

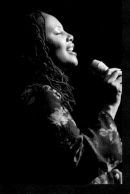
Lalah Hathaway

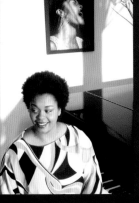
Jill Scott

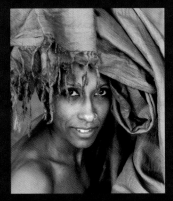
Nia Love

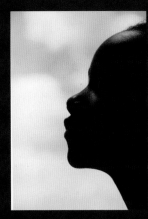
Siobhan

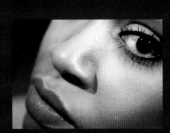
Audrey

Angela Stribling

I was born in Brooklyn N.Y, and my childhood there instilled my love for the arts. As for my talent, that is God Given. As a youngster I sang constantly, entertaining my family. Later on, I studied at Erasmus Hall High School in Brooklyn, as well as Virginia Union University and Brooklyn College. I've been a recording artist since 1988, with a dozen CD's to my credit on Motown, Island, Mercury and Verve Records.

I'm a self-taught photographer who was influenced by music and those photographers who have captured musical images before me, including William Gottlieb, William Claxton, Herman Leonard, Milt Hinton and Carol Friedman, to name a few. I'm married to my loveley wife Audrey, and I have three beautiful children, Will Jr., Siobhan and Aja. The release of this project is yet another dream come true for me!! Enjoy!!!

Will Downing

Birth Date: November 29, 1963

As an "insider" artist/photographer Will Downing's shots of fellow performers – backstage, on stage, in the studio, and candid portraits – allow a more personal glimpse of today's performers. *Unveiled* is a tasteful document of great American art. In this book, we celebrate the diversity and majesty of regal creators of photography, paintings, ceramic works, mixed media and more. Delight and marvel, as you have in your possession a masterpiece of visual elegance worthy of being shared with many.

Dyana Williams, President, International Association of African American Music Foundation, Art Collector

André Guichard

André Guichard's art translates Jazz in visual terms beyond the bandstand. He equates melody and harmony with verdant abundance, where spring is the sole season and bouquets abound, their varied colors akin to chords. He is more than just an accomplished painter, he is also a musician whose instrument just happens to be the paintbrush. There is always rich texture to his work, for the paint is never content to just sit there. His eternal spring paces a song that is ever growing, too, with variations and solos of sorts, though every painting is the work of a palette that is equal to any ensemble in its rich combination of colors.

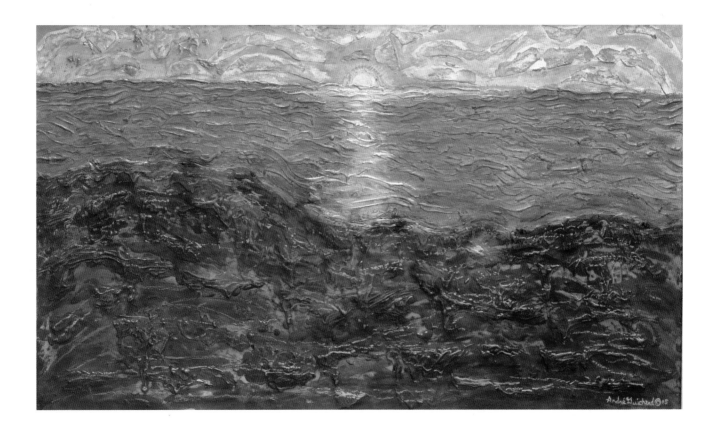

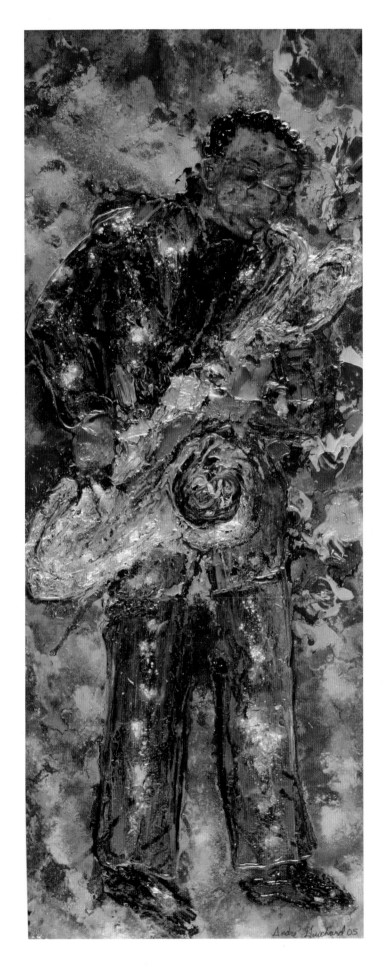

André Guichard 45

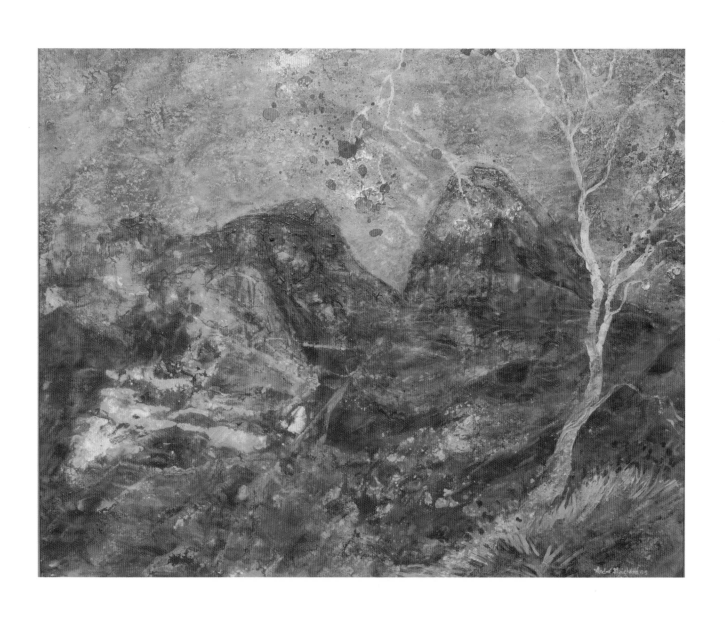

46 André Guichard

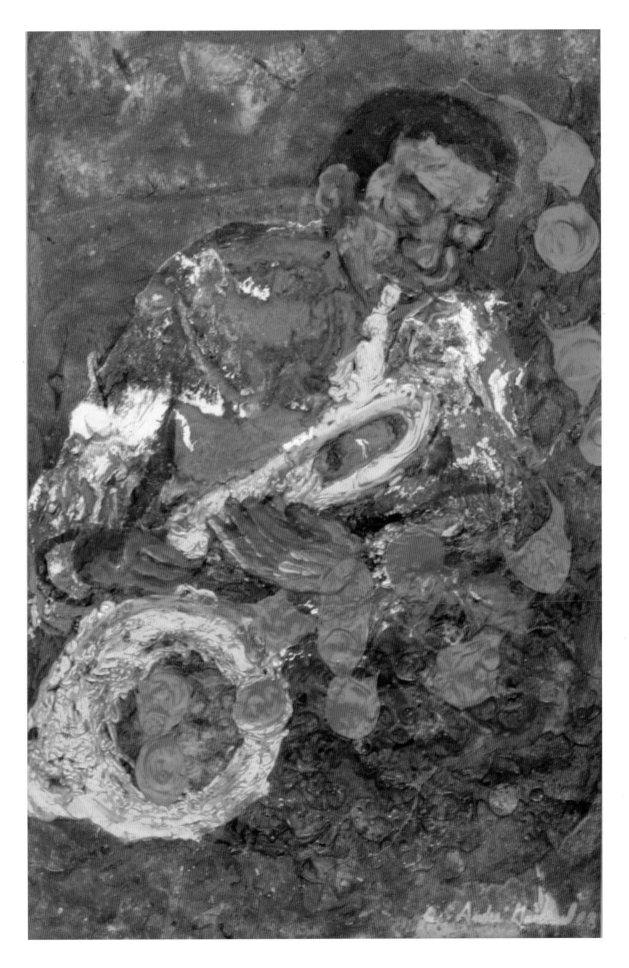

André Guichard 47

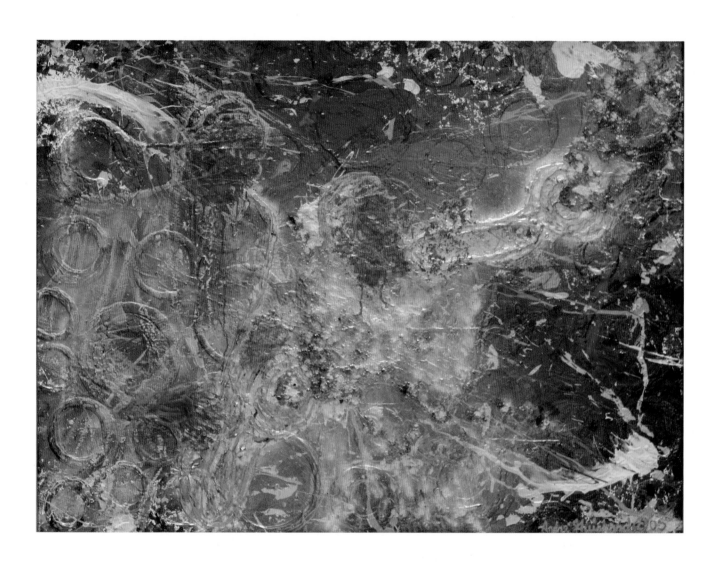

48 André Guichard

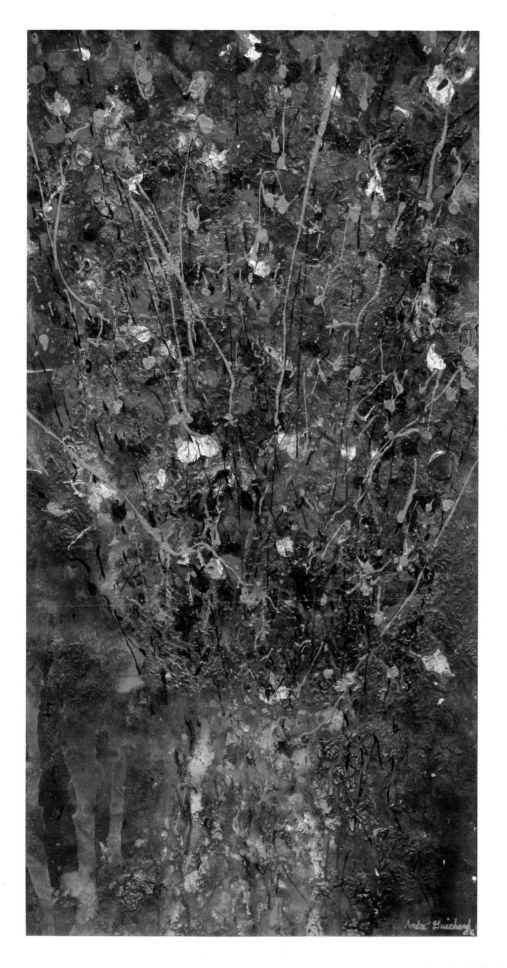

André Guichard 49

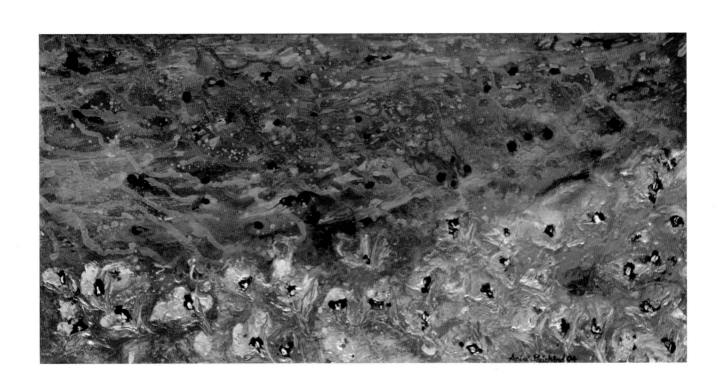

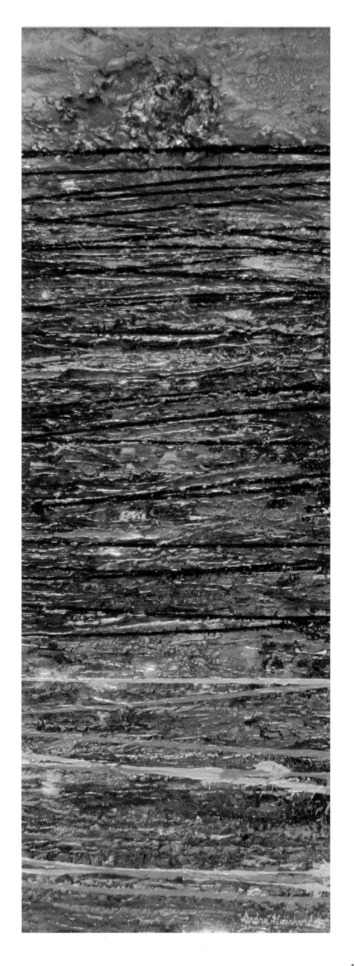

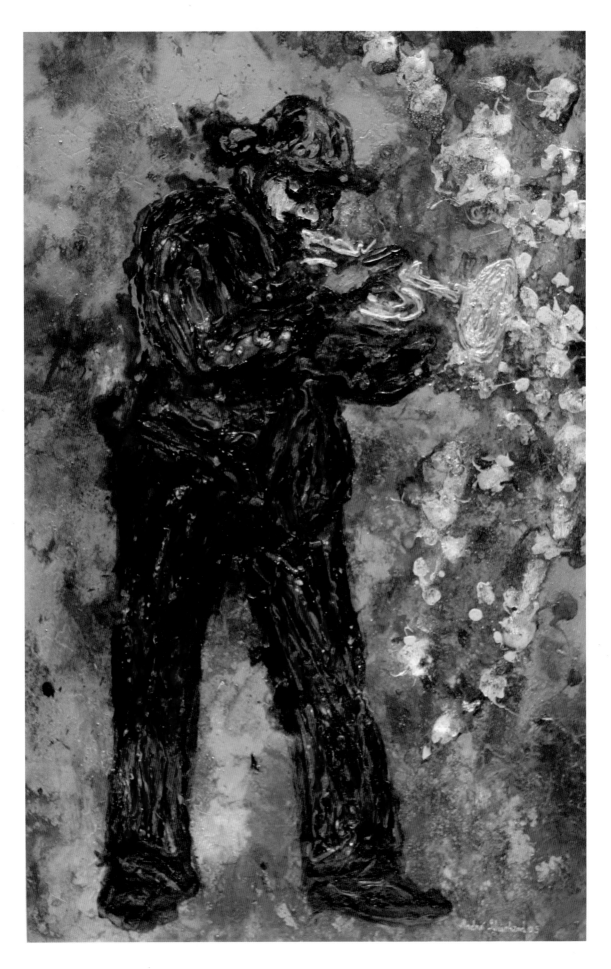

52 André Guichard

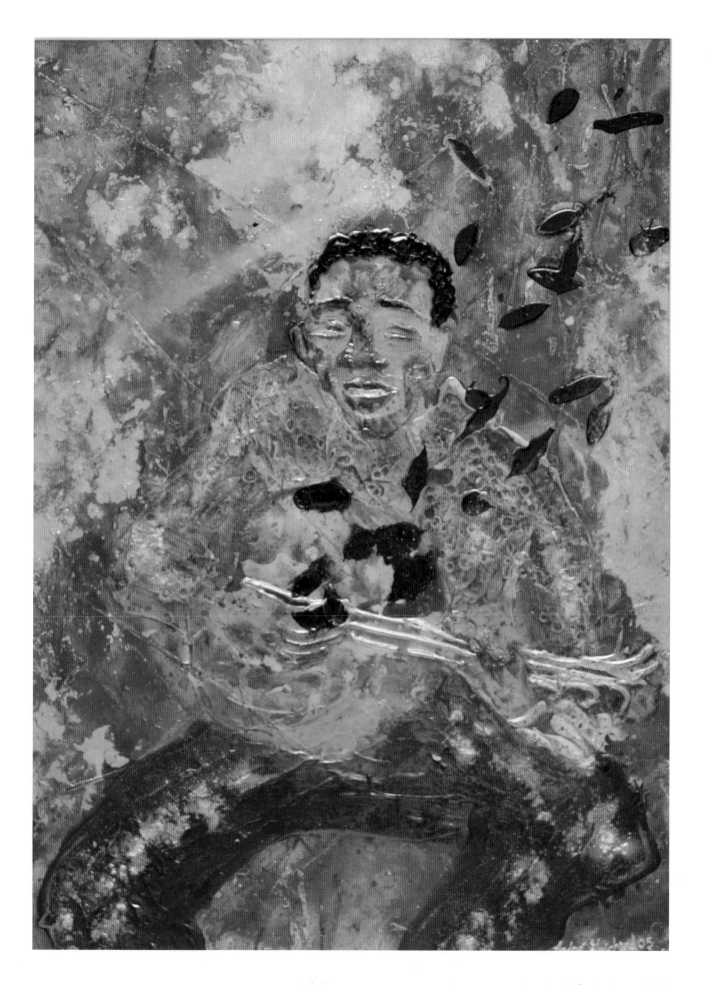

André Guichard 53

"Sunset Over Maui"
34" x 58.5" acrylic/ mixed media

"Southwestern Abstract"
Bouquet 48" x 24"

"One With My Music"
45"x 29" acrylic/mixed

"Jazz Vibrations"
35"x47.5" acylic/canva

"Purple Haze"
30" x 19" acrylic/canvas

"Sweet Strings"
38" x27" acrylic/canvas

"Placid Sunset I"
47" x 17" acrylic/canvas

"Bass Sax On Fire"
52" x 20" acrylic/mixed

"Flowers on the Beach"
24" x 48" acrylic/canvas

"Mother Earth II"
45"x 55.5" acrylic/mixe

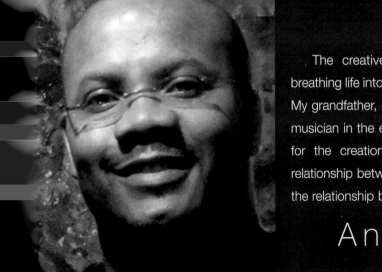

The creative process for me involves taking thoughts
breathing life into them. My love for jazz stems from my personal r
My grandfather, Alfred Guichard Sr. was a famous New Orleans
musician in the early 1930's. Knowing my family roots was a cat
for the creation of an ongoing Jazz series that expresses
relationship between Jazz music and the painted abstract, as we
the relationship between musician and instrument.

André Guichard

Date of Birth: 12-11-66

Education: Illinois State University, Bachelor of Science

It is important to document works of significant artists who are creating today's powerful images. This book gives deserved exposure to a cross-section of today's working artists. It brings art to the attention of the collecting public—preserving, not just master works but art of an emerging group, from which masters of the future will surely come. Congratulations to the publishers as they add to the growing body of literature long overdue to help set the record straight.

Paul R. Jones, Art Collector

Calvin Coleman

Calvin Coleman celebrates life whenever he paints. A kinetic energy courses through his work that yields joy, which in turn transcends emotions to become its own reality. Still, his range recognizes solitude as well, and the aspect of loneliness that is sometimes found there. Yet this is offset by the body of his work, which is offered in a palette that paces the exuberance of his subjects and themes. Even if a figure is standing still, Coleman unveils the movement that is an implicit dance of the spirit. Indeed, his approach to painting is choreographic, as he reveals that people are often dancing even if they're unaware of it.

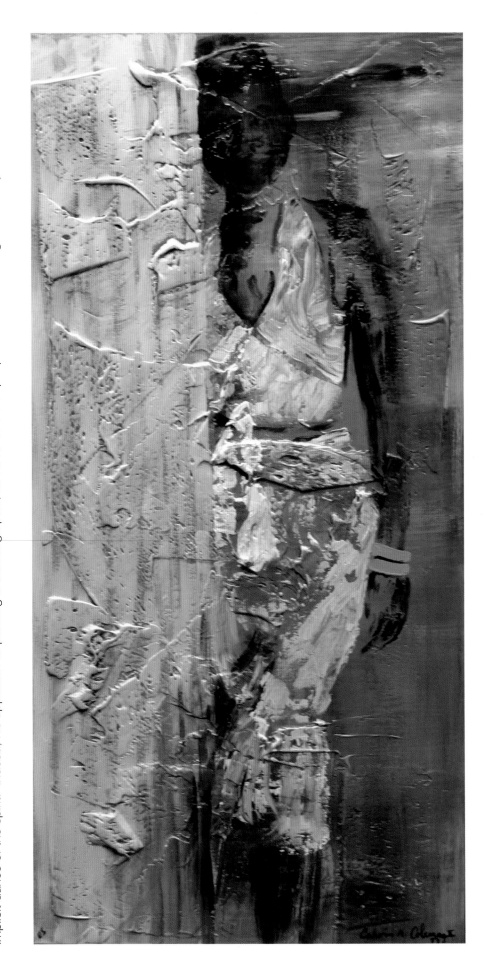

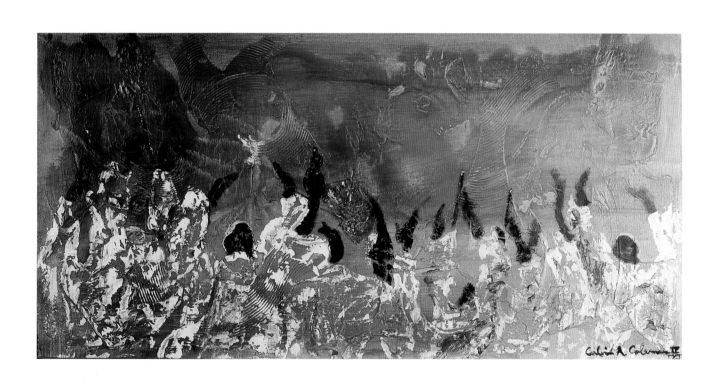

57 Calvin Coleman

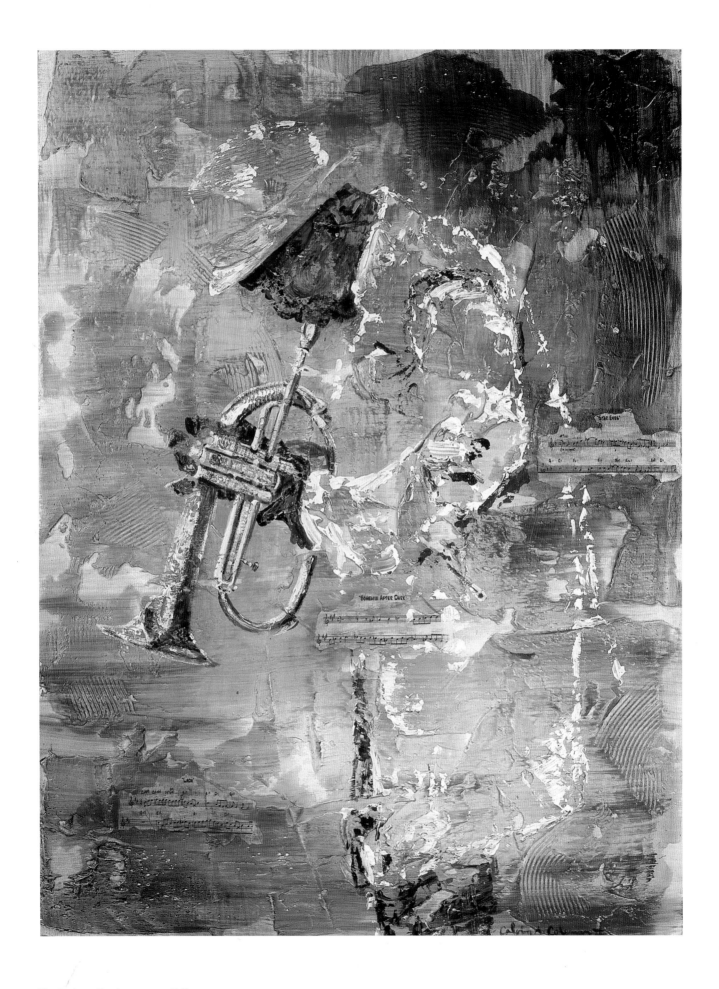

Calvin Coleman 58

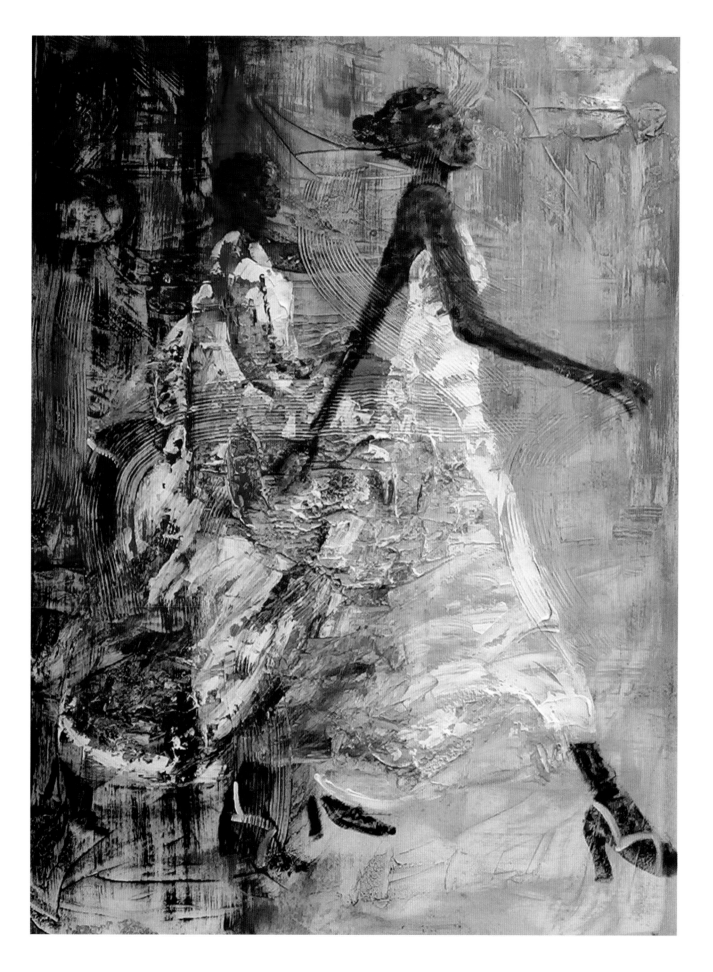

59 Calvin Coleman

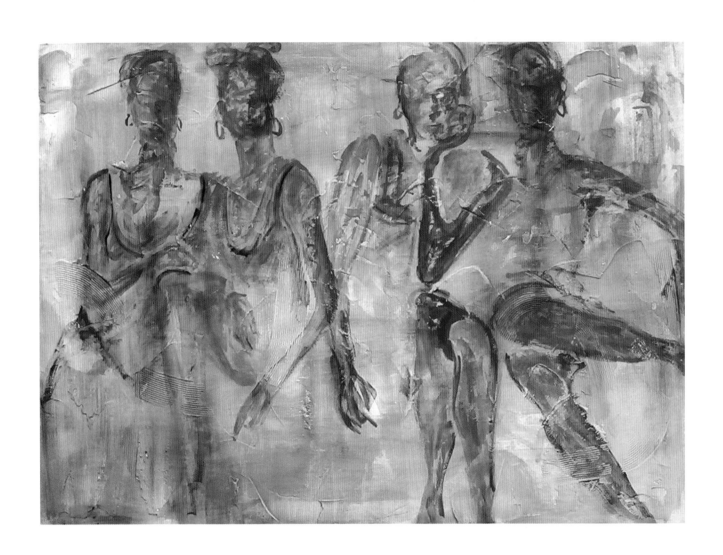

Calvin Coleman 60

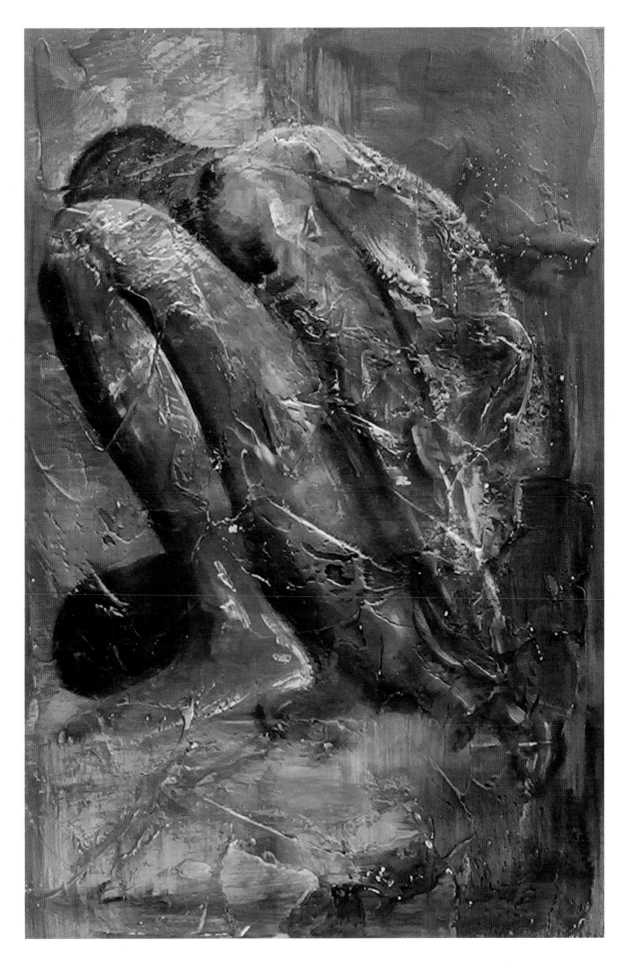

61 Calvin Coleman

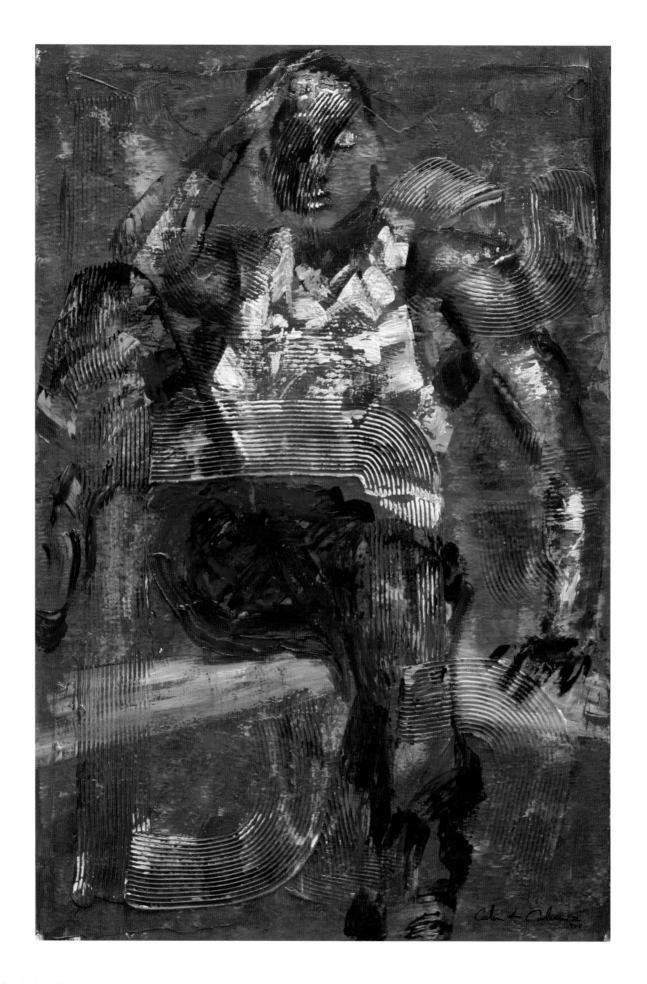

Calvin Coleman 62

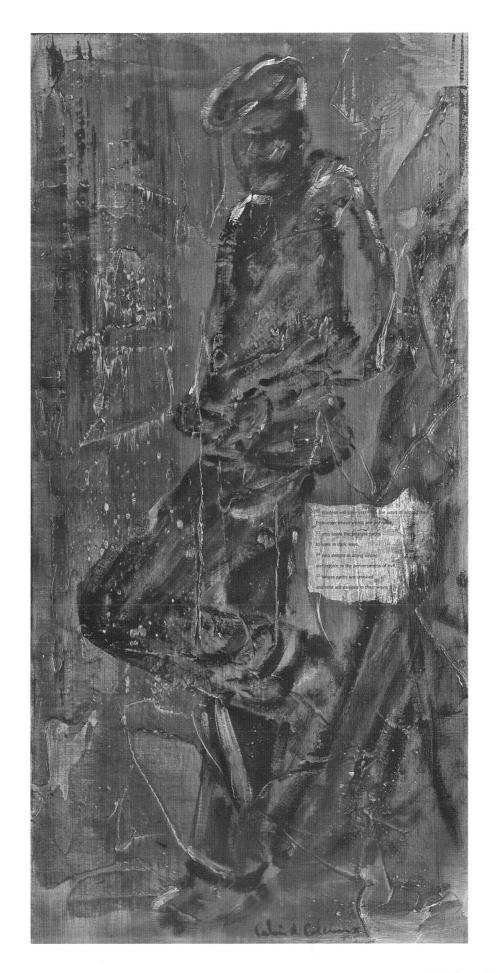

The text on the paper within the image reads:

> Wisdom will save you from the ways of wicked men,
> from men whose words are perverse,
> who leave the straight paths
> to walk in dark ways,
> who delight in doing wrong
> and rejoice in the perverseness of evil,
> whose paths are crooked
> and who are devious in their ways.

63 Calvin Coleman

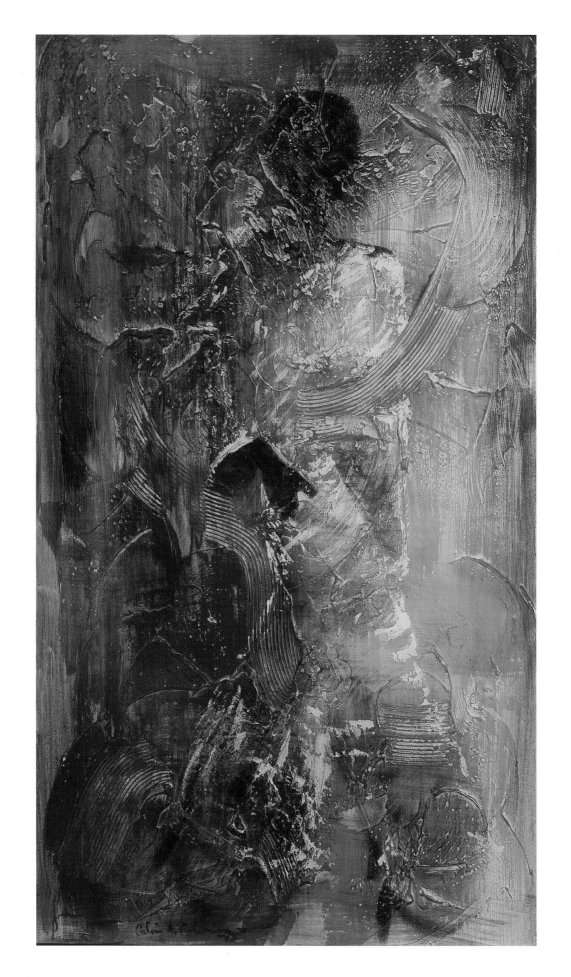

Calvin Coleman 64

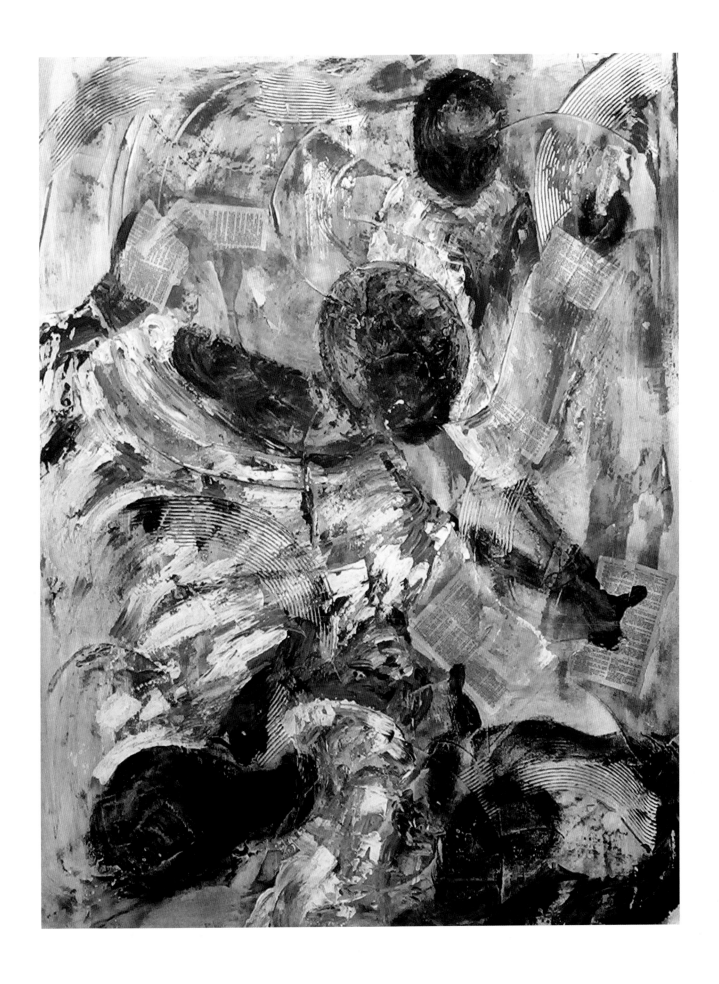

65 Calvin Coleman

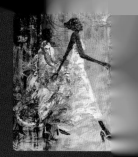

"He is My Pillar"
24" x 48"
Acrylic/Mixed Media

"Joy Comes in the Morning"
24" x 48"
Acrylic/Mixed Media

"Roy Hargrove"
30" x 40"
Acrylic/Mixed Media

"He'll Bring Me Through Th[e]
36" x 48"
Acrylic/Mixed Media

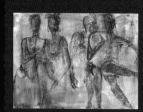

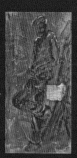

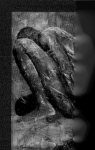

"The Fellowship"
52" x 64"
Acrylic/Mixed media

"Lean On Him"
18" x 36"
Acrylic/Mixed Media

"Even Gold Goes Through Fire"
24" x 42"
Acrylic/Mixed Media

"Every Knee Sha[ll]
24" x 36"
Acrylic/Mixed [Media]

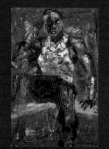

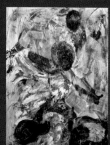

"Alone But Not Alone"
24" x 36"
Acrylic/Mixed Media

"Hungry Minds"
Acrylic/Mixed Media
36" x 48"

My work is constructed and designed to uniquely
encourage and ignite the senses through an abstract sens[e]
imagination. With profound manipulated texture, each piec[e]
has its purpose in touching a person's soul. Using a wide s[pectrum]
of deep rich colors, I look to send a message to the onloo[ker]
will not only capture their eyes but their emotions as wel[l]
each work of art, my spiritual influences, love for music and
true beauty, are all reflected in my compositions.

Calvin Colema[n]

Birth Date: July 2, 1966
Education: B.S. Lincoln University, Lincoln Pa
Early Childhood Education,

Unveiled is a breathtakingly beautiful excursion into the depths of several brilliantly talented artists. As an art collector of the African Diaspora for over two decades, I am profoundly impressed with this collection of new and emerging artists works. Owners Pamela Brown and Beverly Dawson of ArtJaz Gallery in Old City Philadelphia, have curated an eclectic and dynamic mix of outstanding images that evoke great emotion.

Dyana Williams, President, International Association of African American Music Foundation, Art Collector

Katherine Kisa

Geometry plays a large part in Katherine Kisa's art. However, she doesn't opt for any abstract impulse. Rather she finds technology to hold sway, and vintage technology at that. While most people equate turntables today with Hip-Hop, Ms. Kisa sees them as the optimum devices for playing Jazz in LP form. The mixed media aspects of her work serve as collage elements that are still painterly, these vinyl platters relics of a bygone era. For this artist, music is a system of logic, notes on paper akin to equations, while art is more mysterious. Still, both are confluent as a force that yields its own life.

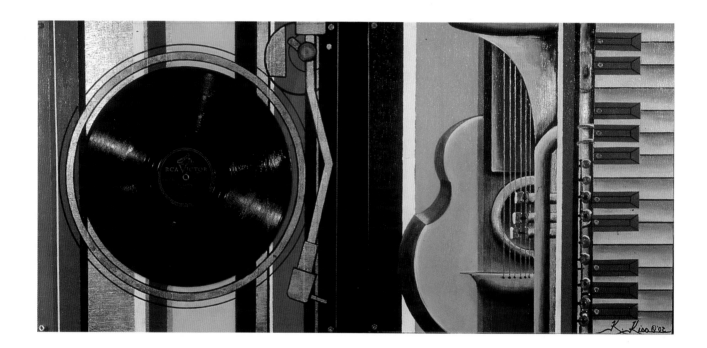

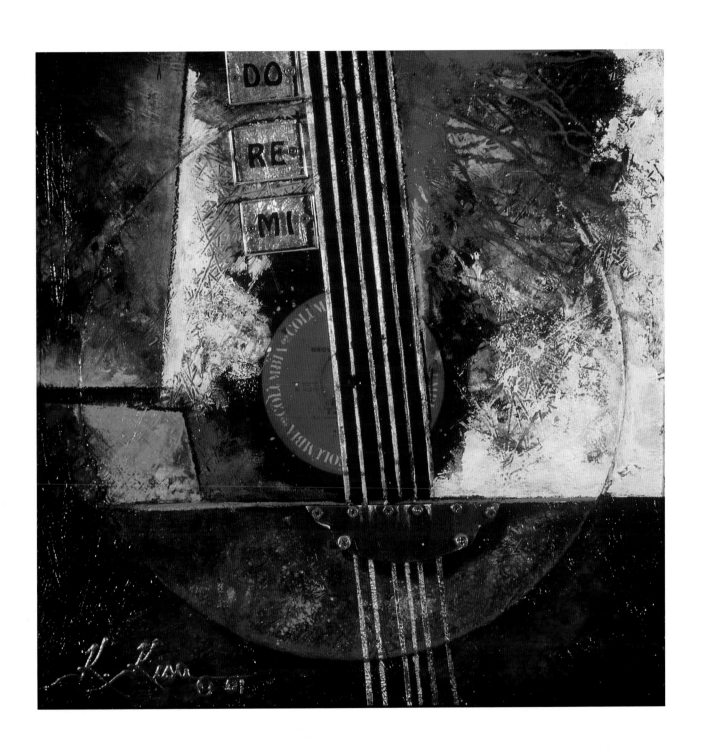

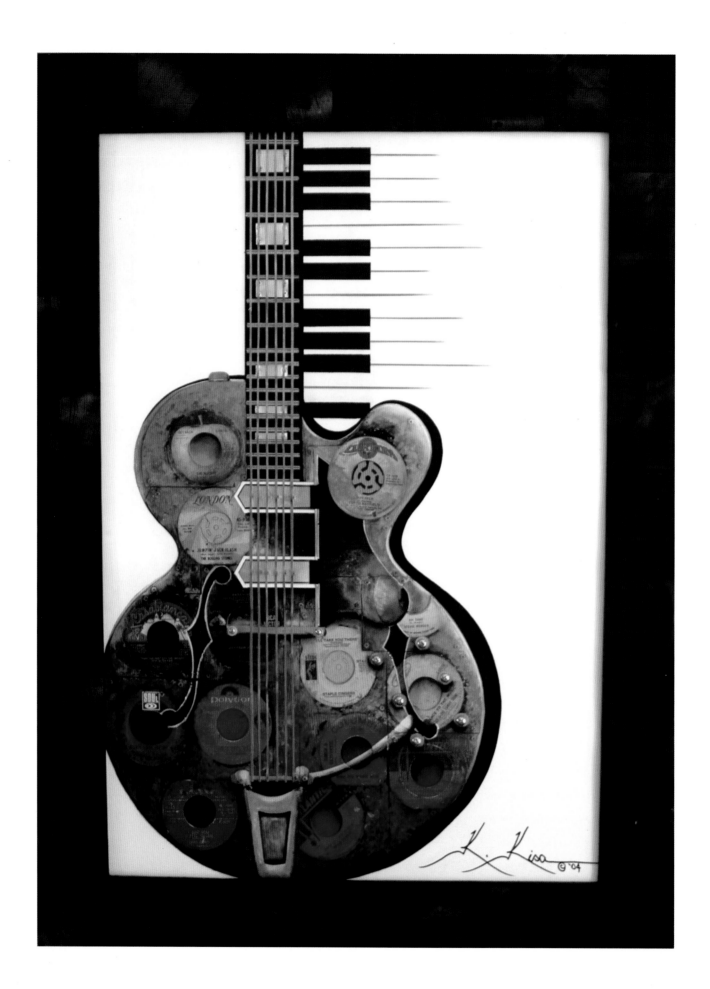

70 Katherine Kisa

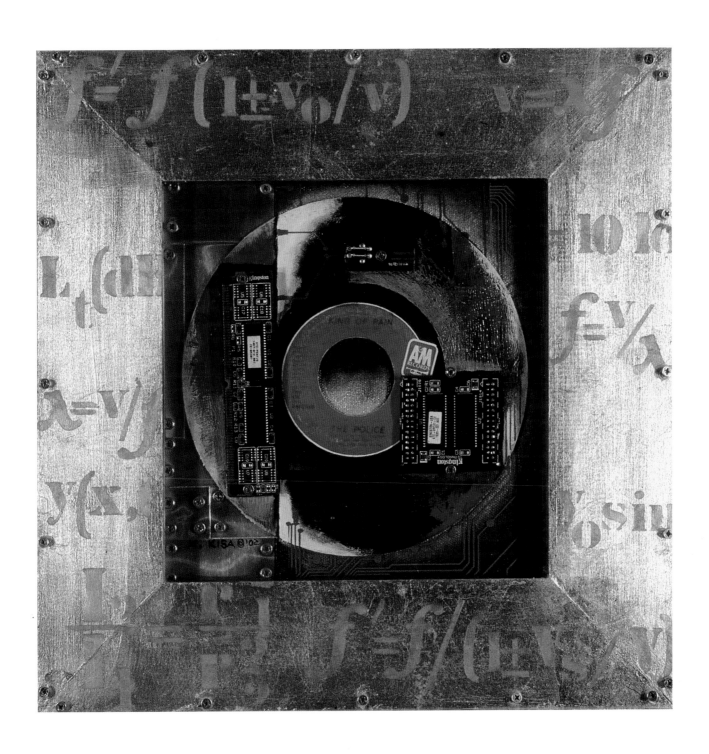

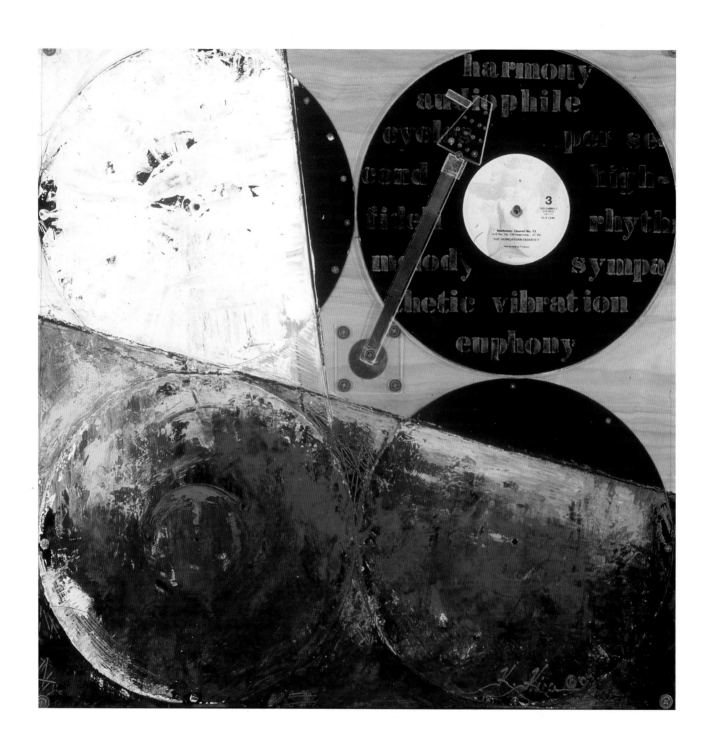

72 Katherine Kisa

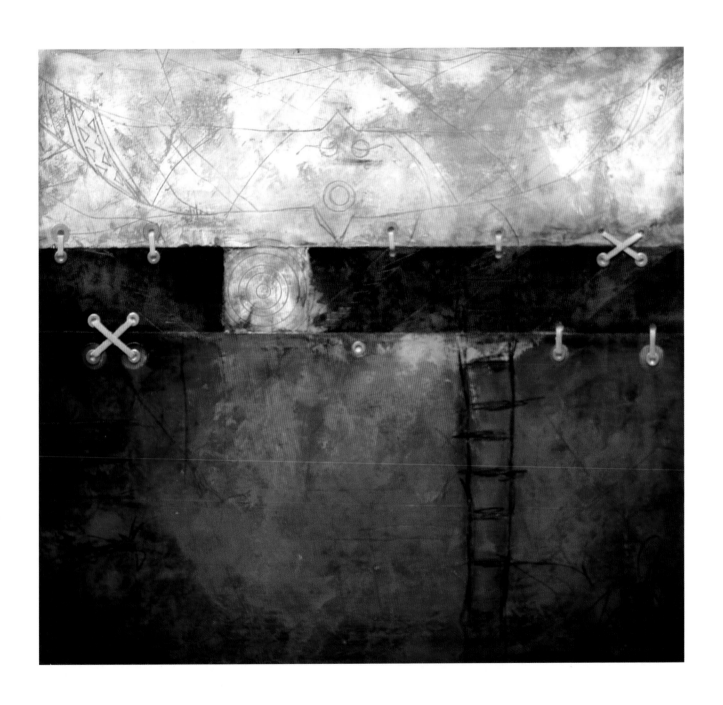

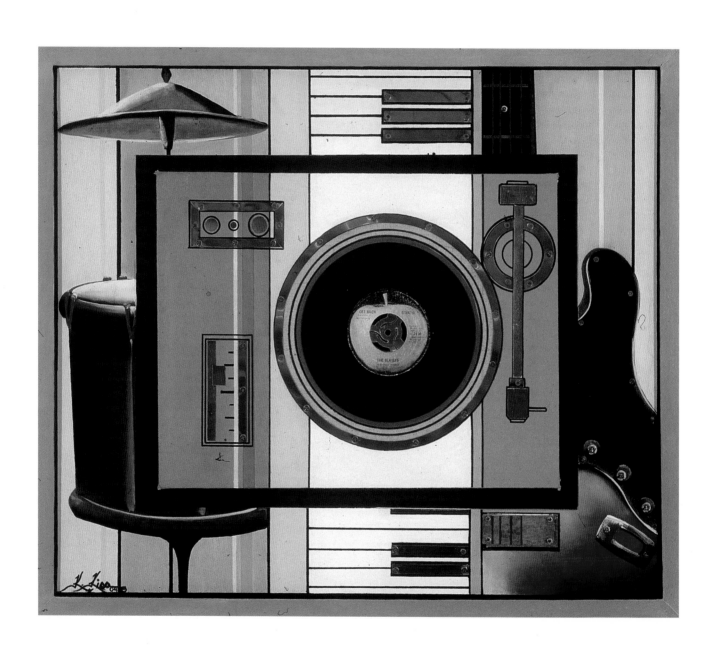

74 Katherine Kisa

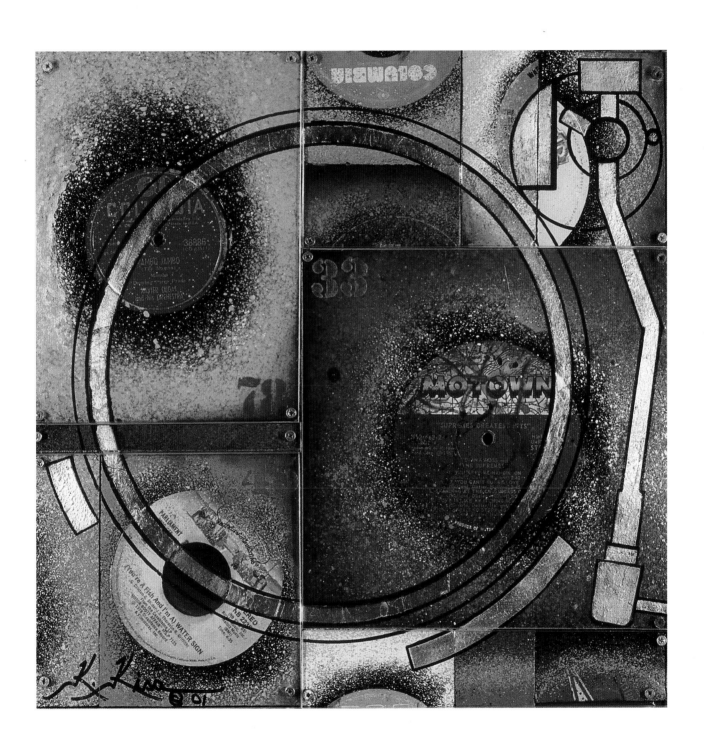

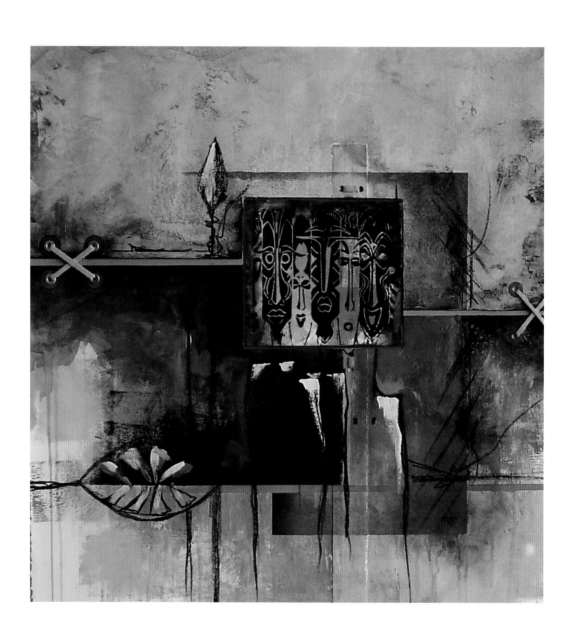

76 Katherine Kisa

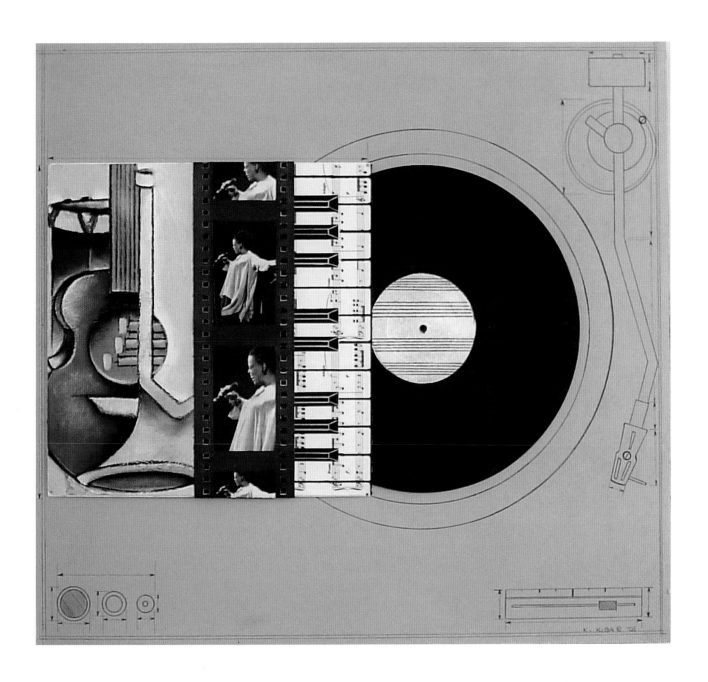

"Jalousie"
vinyl record assemblage
Mixed Media

"DO-RE-ME"
vinyl record assemblage
Mixed Media

"Stereophonic Ecstasy"
Vinyl Record Assemblage
Mixed Media

"King of Pain"
vinyl record assemblage
Mixed Media

"Audio Nectar"
vinyl record assemblage
Mixed Media

"Ascent of the Ancient Bird"
Mixed Media on paper

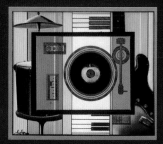

"The British Invasion"
vinyl record assemblage
Mixed Media

"Audiophile"
vinyl record assemblage
Mixed Media

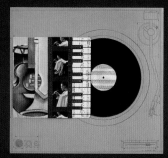

"Sentinels"
Mixed Media on Rag paper

"Song Bird"
Acrylic on paper

I have always been fascinated by music and the wide variety of machines and instruments involved in its production. This series of paintings, called "Audio Nectar," illustrates the complexity and close association between the mechanical, instrumental, and artistic components of music. Color is added with oil or acrylic paint as a possible interpretation of how musical scores may appear. Although we are firmly entrenched in the digital age, I create my pieces with the first item which started my intense love of music, the vinyl record, the precursor to CD, MP3 and other digital formats. In addition, I use found objects such as old record player components and computer parts to create the assemblages. These are subsequently painted to reflect a range of musical styles from the simplest ballads to the most complex symphonies.

Katherine Kisa

Birth Date: February 16, 1967
Education: B.S. Biology, University of Toronto
Graduate studies in biology Emory University

As a collector I find that collecting Art from artists that are new and emerging is quite refreshing. These artists some of whom are self-taught and who have apprenticed and or collaborated with African American Artist of historical significance have grabbbed in my view the essence of what I as a collector look for when acquiring art from this wonderful group of artists. It is a terrible folly for a collector of any sort not to have an appreciation for these works.

Adrian J. Moody, Esq., Art Collector

Kimmy Cantrell

Kimmy Cantrell channels spirits. He also collapses time to link yesterday with tomorrow. His work brings to mind the credo of the Art Ensemble of Chicago: "Ancient to the Future." The timelessness of his ceramics yields a sacred life that courses through his veins. Through them he nullifies The Middle Passage by returning to Africa, with each work an expression of High Life. Yet America doesn't disappear altogether, as his art also embodies a freedom based on what he achieves through creation, the connection with Jazz his energy of composition while his purpose is not art for art's sake but art for heart's sake.

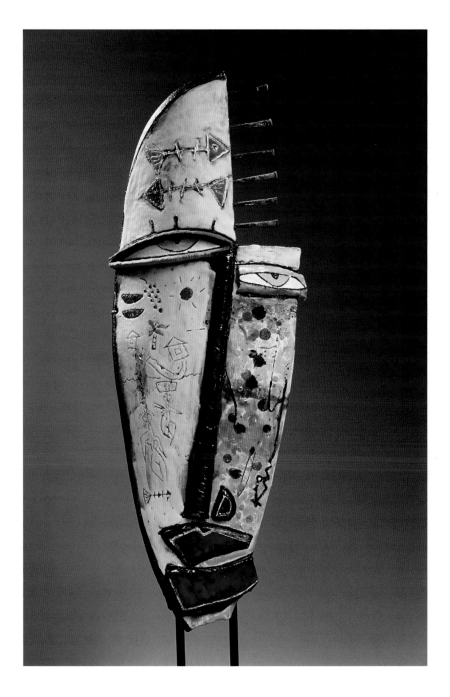

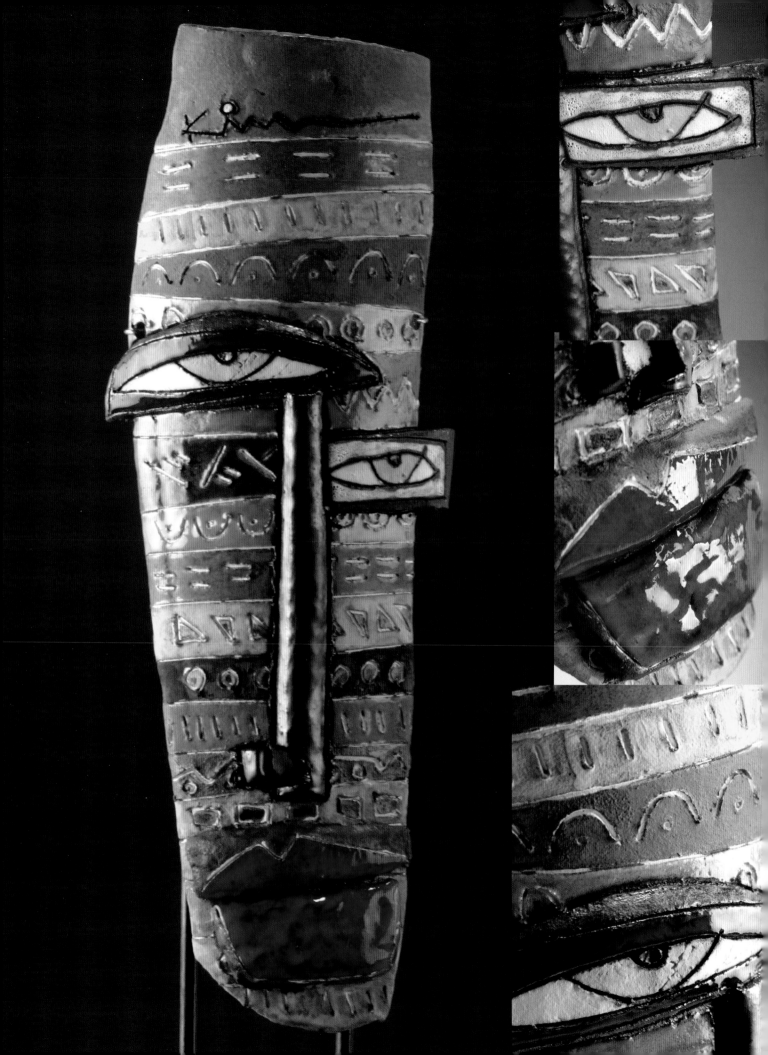

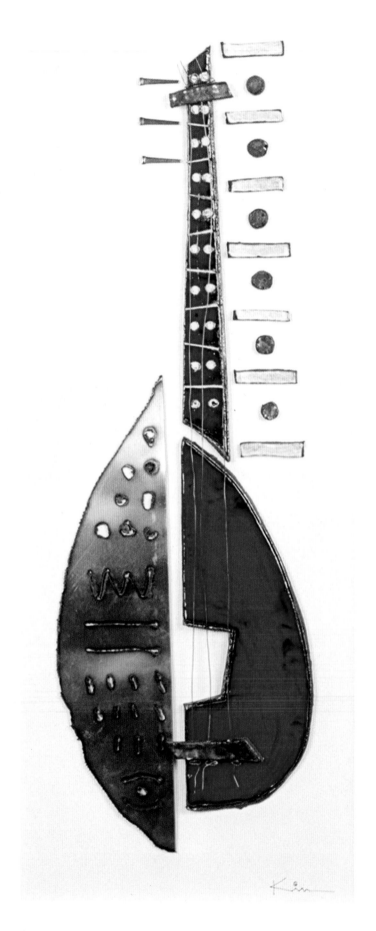

Kimmy Cantrell 82

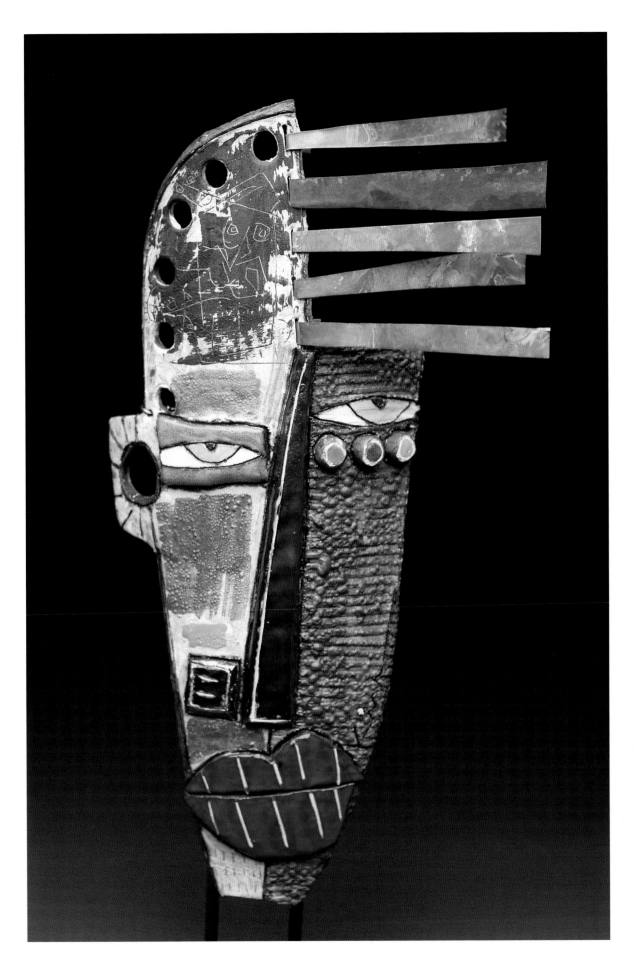

83 Kimmy Cantrell

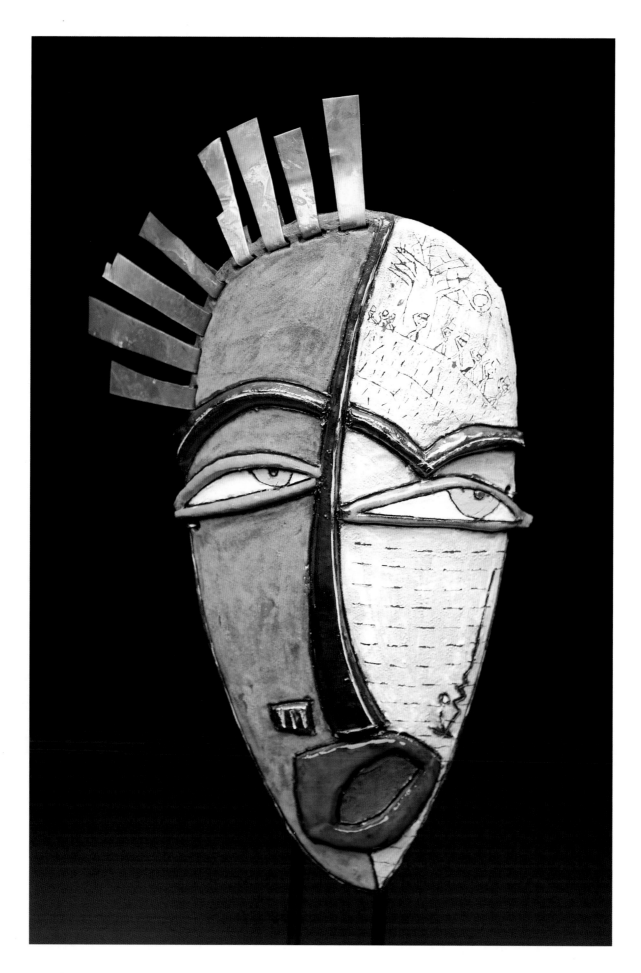

Kimmy Cantrell 84

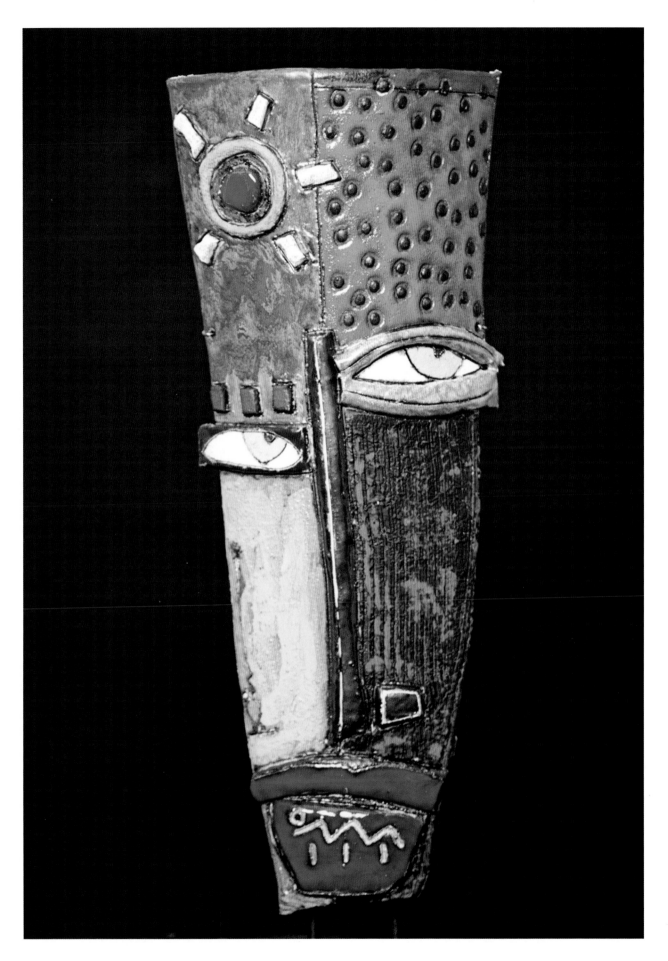

85 Kimmy Cantrell

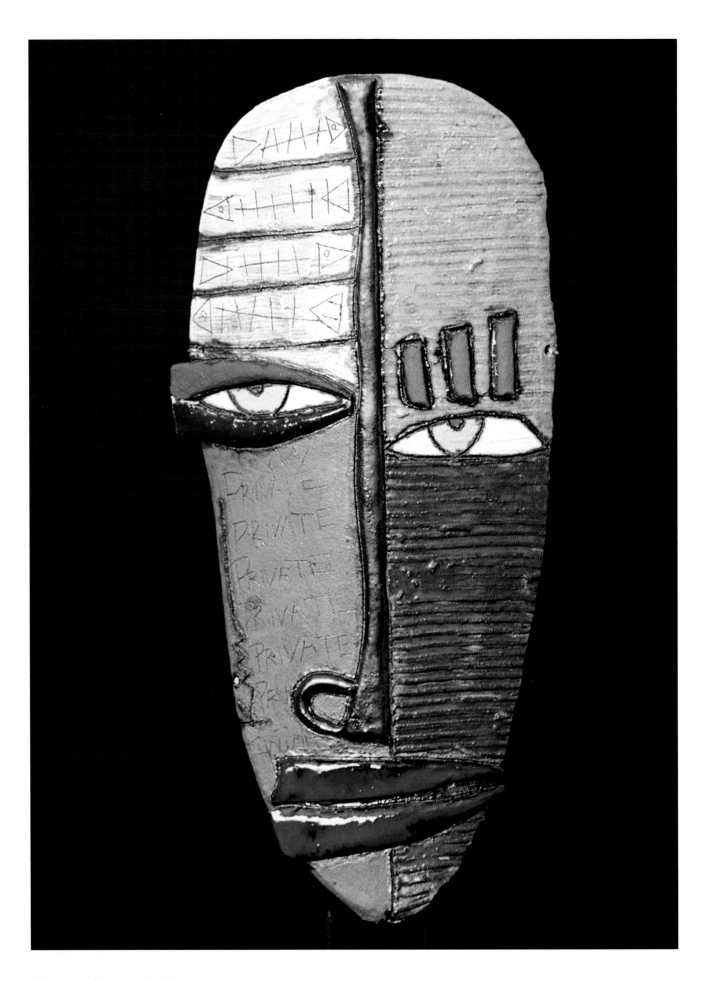

Kimmy Cantrell 86

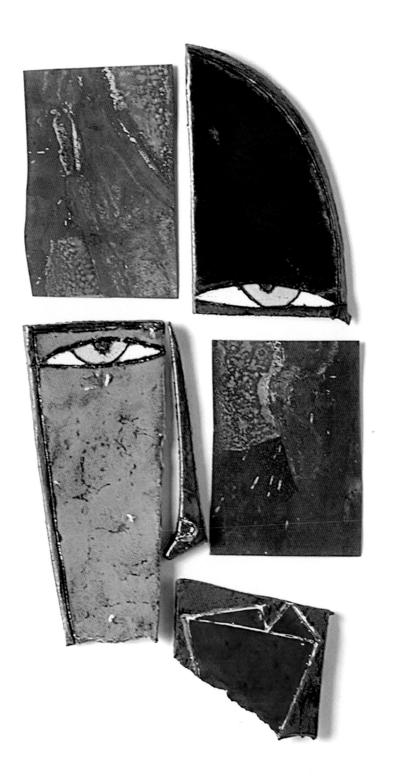

87 Kimmy Cantrell

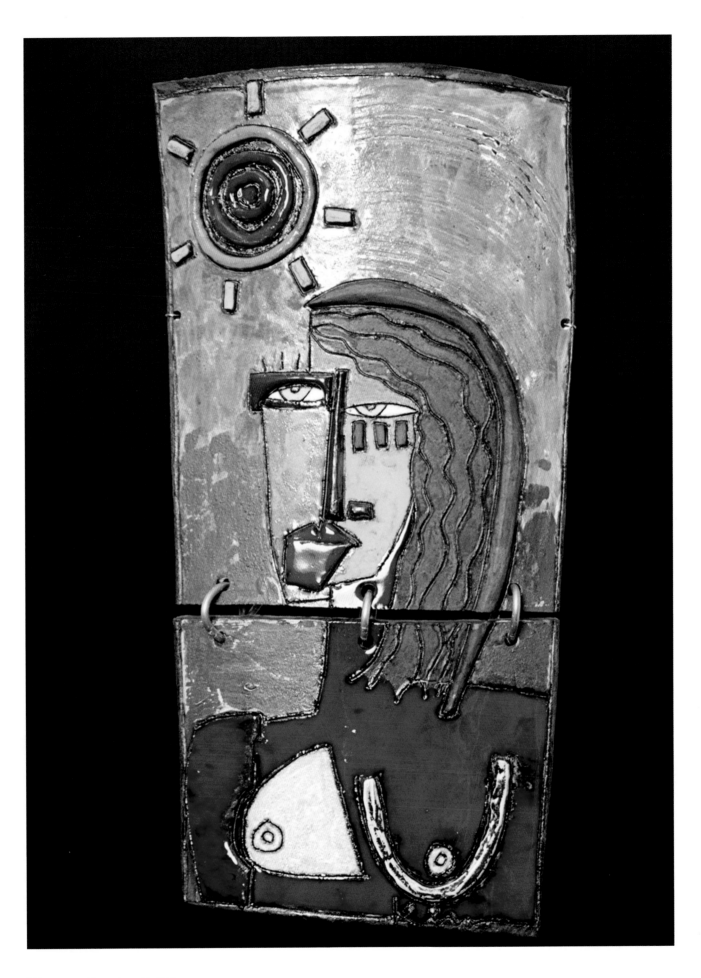

Kimmy Cantrell 88

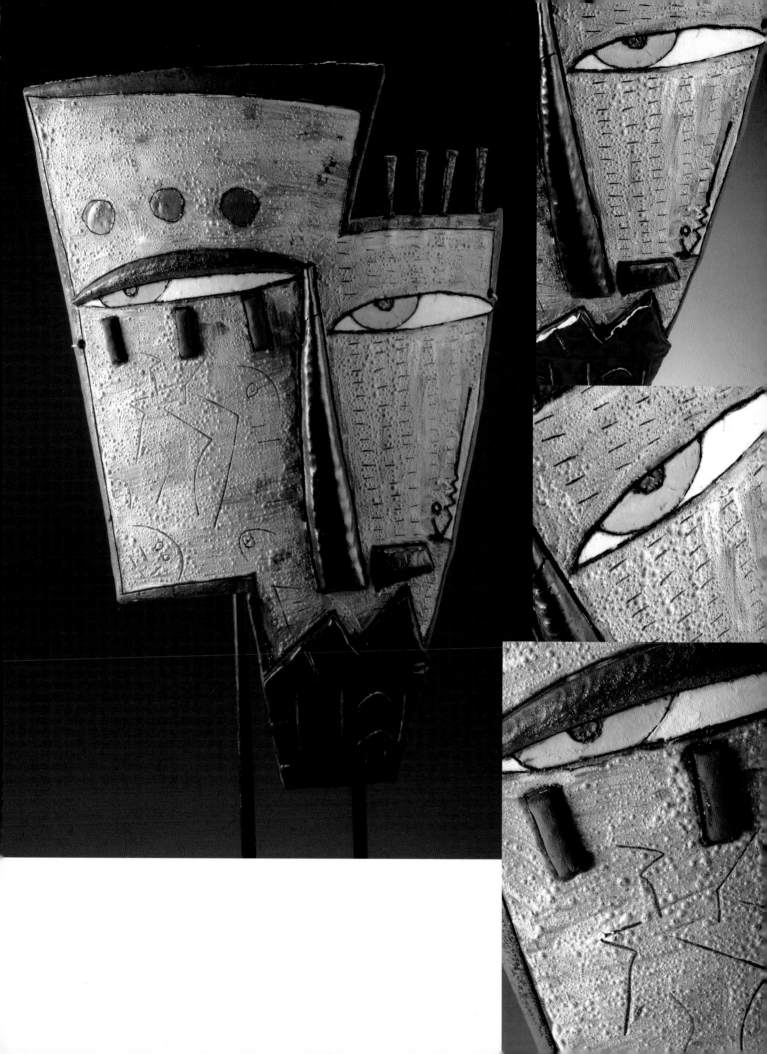

"In Disquise"
15" x 26"

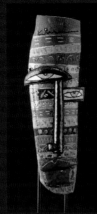

"Reflections of the Past"
7" x 16"

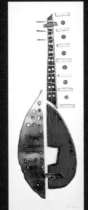

"Strings and Keys"
24" x 49"

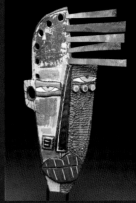

"Blue Me"
9" x 23"

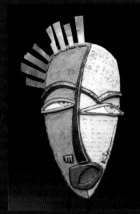

"Under The Baobob Tree"
12" x 22"

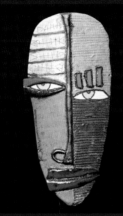

"Day In The Sun"
10" x 26"

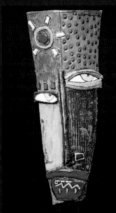

"Private Thoughts"
10.5" x 21"

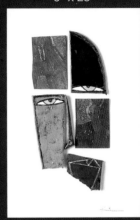

"Pieces of Me"
28" x 19"

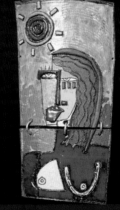

"Lovely You"
14" x 27"

"In Disquise"
15" x 26"

I want to move people with the passion expressed in my work. I want to show the beauty within flaws. Imperfections tell stories that are far more compelling than perfection.

Kimmy Cantrell

Date of Birth: October 22, 1957

Education: Georgia State University

Major Business Administration

My first experience was of excitement, and then I was captured by the paintings on display in this small yet intimate gallery. That was four years ago at their first location, and I had no idea I would acquire a wonderful collection of diverse artists works. Pam and Beverly will take you from being an art enthusiast to a grateful collector. And for me ... that's ArtJaz.

James Logan, Art Collector

Marcel Taylor

Elemental and provocative, Marcel Taylor makes the city at night his own. His work is Cool, his compositions deft expressions of rain soaked streets. There is something hallucinatory here as well, off center, like a tune by Monk. And also like the music of Thelonius Sphere, his art is of this world but of his own private one as well. His creations are charged with an energy that finds the city as an entity unto itself, more than a place but a state of mind. His urban landscapes are mythic, pit stops on a journey through streets given over to neon and distant thunder fading fast.

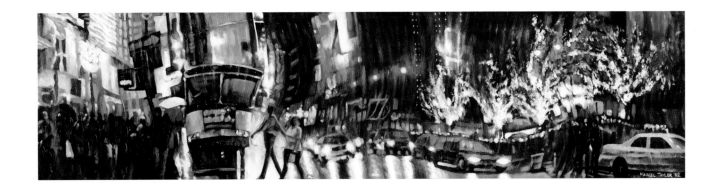

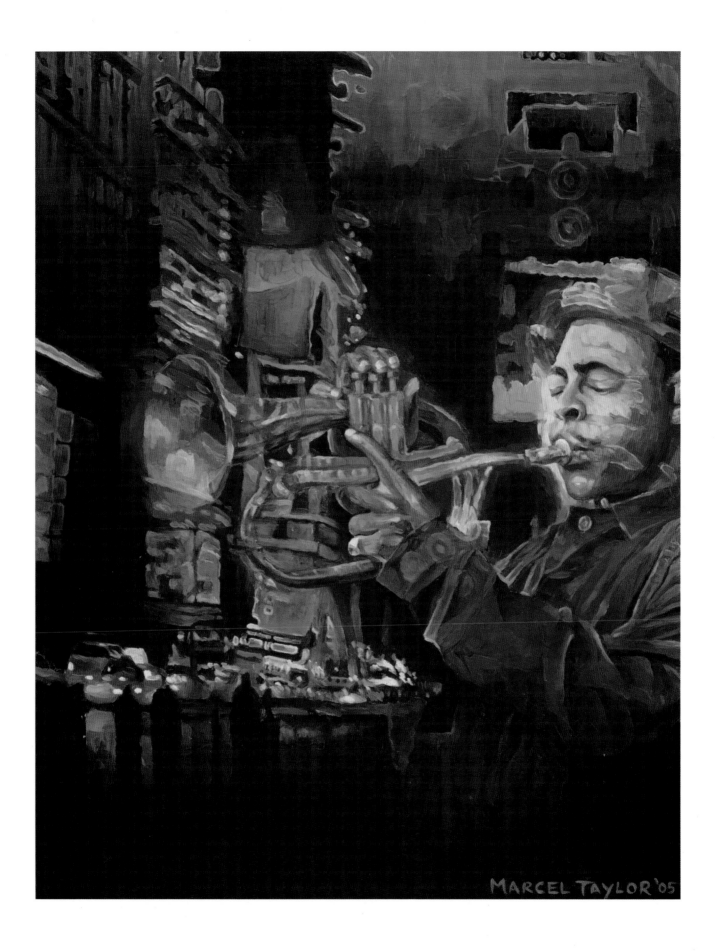

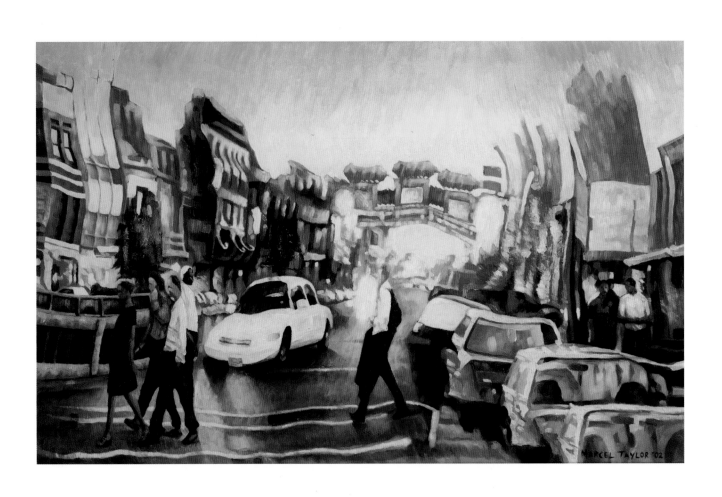

94 Marcel Taylor

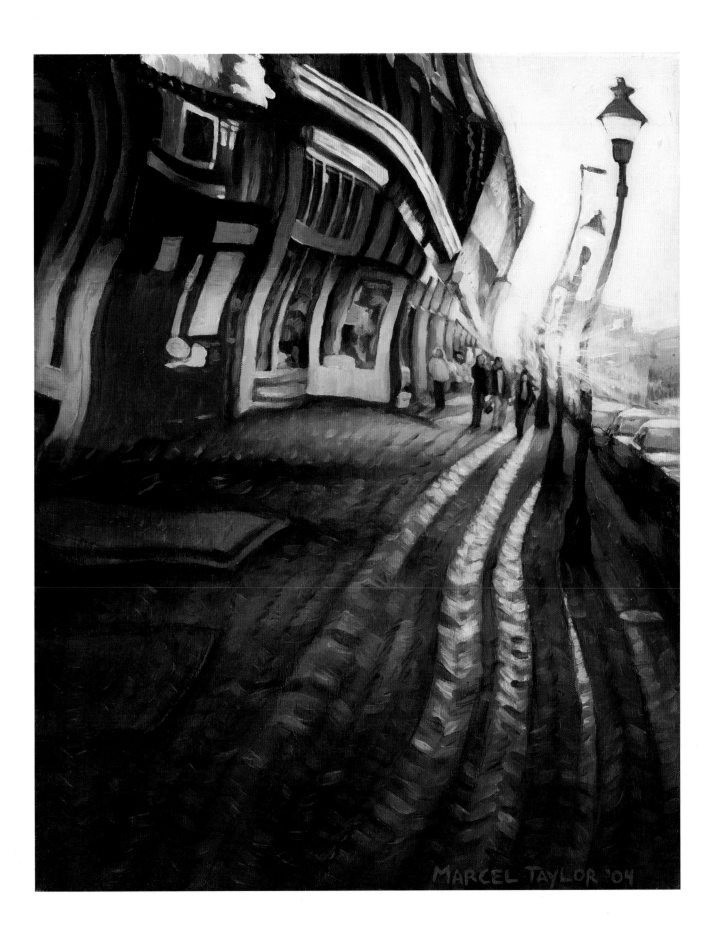

Marcel Taylor 95

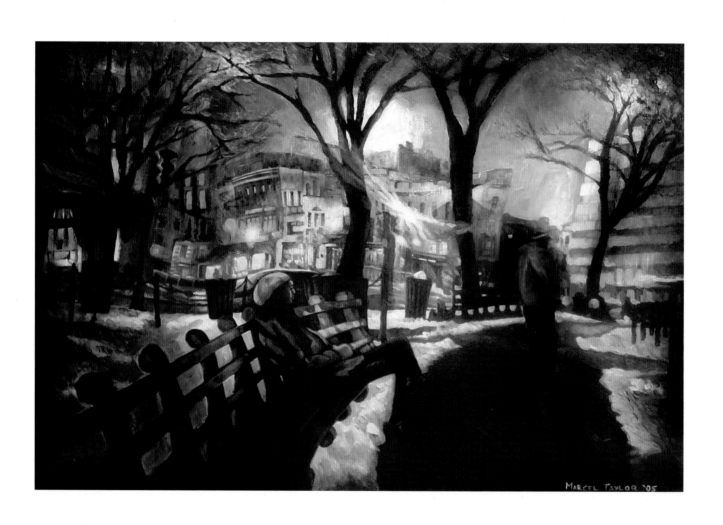

96 Marcel Taylor

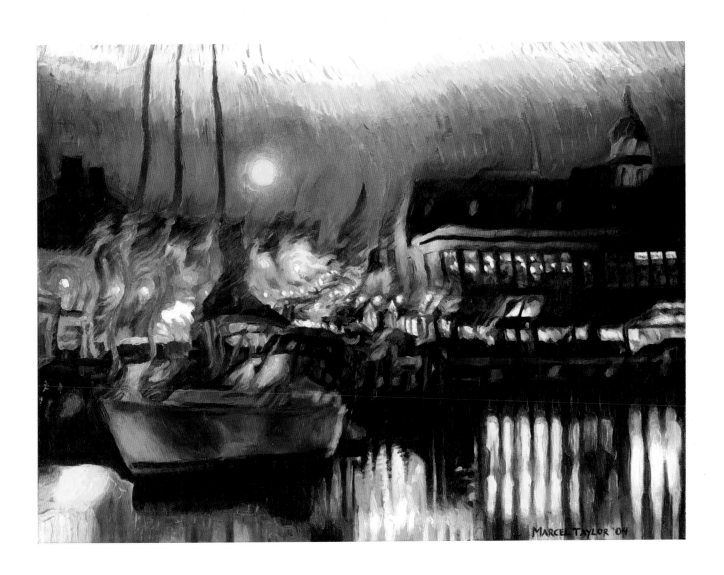

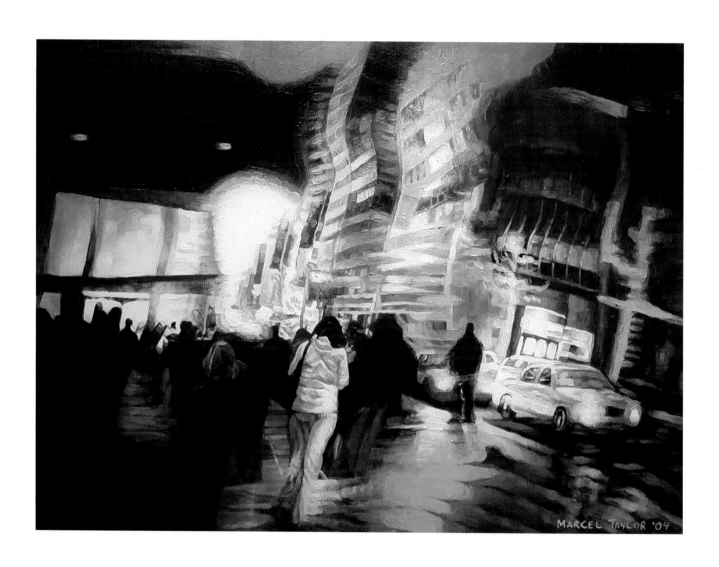

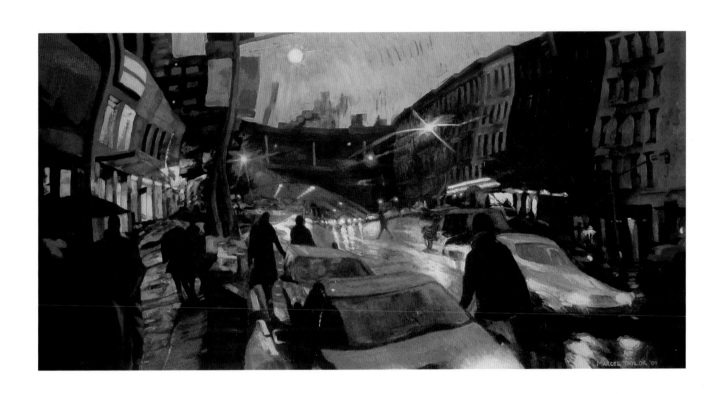

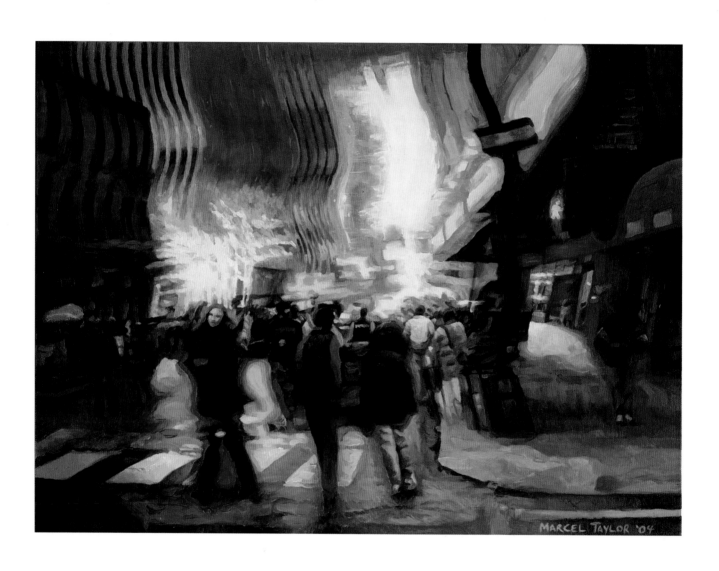

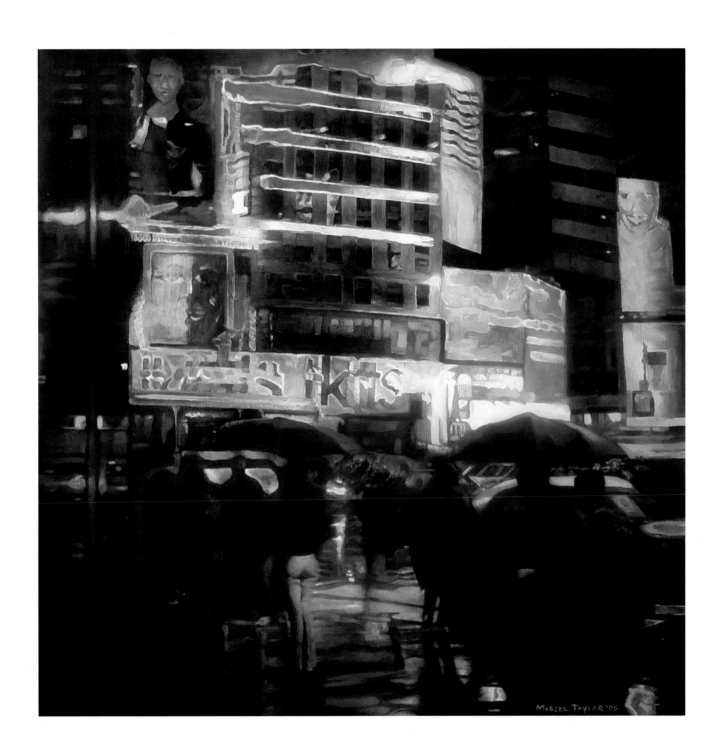

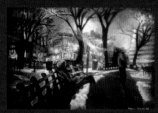
"Blue Drizzle"
12" x 72" / Acrylic on canvas

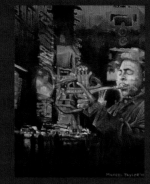

"Seductive Melodies"
20" x 16" / Acrylic on canvas

"Chinatown"
30" x 48" / Acrylic on canvas

"Ruby Sidewalk"
20" x 16" / Acrylic on canvas

"Cold Shoulder"
24" x 36" / Acrylic on canvas

"Still Waters"
18" x 24" / Acrylic on canvas

"Tunnel Vision"
18" x 24" / Acrylic on canvas

"Nonchalant Shadows"
24" x 48" / Acrylic on canvas

"The Wanderer"
18" x 24" / Acrylic on canvas

"Wonderland"
36" x 36" / Acrylic on canvas

The transition of metropolitan space from daily routine to its nocturnal character reveals a fascinating transformation of color. My current series of paintings, CITYSCAPES, is a bold collection of paintings that portrays the various moods of urban space by capturing its qualities of light, shadow, and symmetry. They illustrate how I view urban places. More than just urban landscapes, they are my interpretation of the rhythmic and ambient qualities or urban space.

Marcel Taylor

Date of Birth: February 9, 1970
Education: Howard University, 1992
Bachelor of Fine Arts (BFA)

I have been collecting the works of African-American artists since the 80's. My first purchase was a lithograph by Romare Bearden. Over the years, I have continued to collect principally contemporary artists, most of whom have been emerging and mid – career artists. I have had the unique pleasure to get to know many of the artists whose work I have collected. I think it is important to support contemporary emerging artists who will become the "master artists" of the next generation.

Randi Gilliam, President, RAL Productions, Art Collector

Paul S. Benjamin

Cascades of color and impromptu forms course through the work of Paul S. Benjamin. It is all about what is necessary, with nary a hue or image out of place. Yet for all this precision, there is a flamboyant feel to his work that is built on surprise. He also tips his hat to those who came before him, especially Romare Bearden. He offers art imbued with an understated yet ever bold elegance, a sophistication that finds him finishing every piece with a wry twinkle in his eye. Yet his are not private jokes, but pictorial documents that he shares with a gracious reverence.

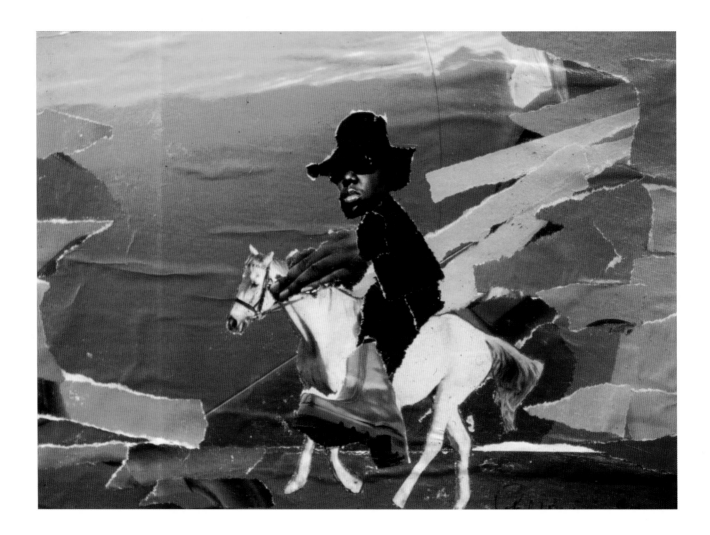

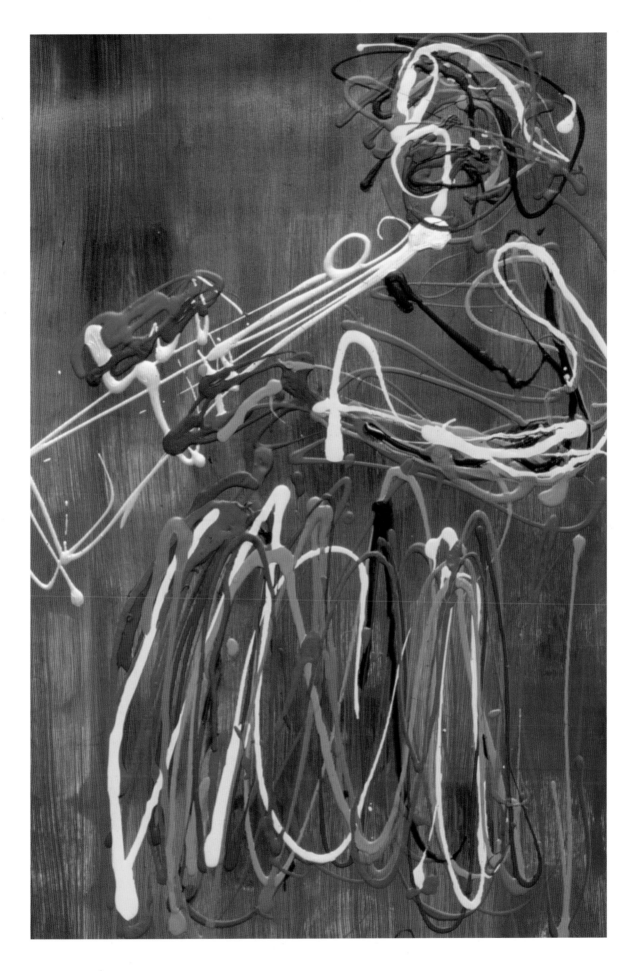

105 Paul S. Benjamin

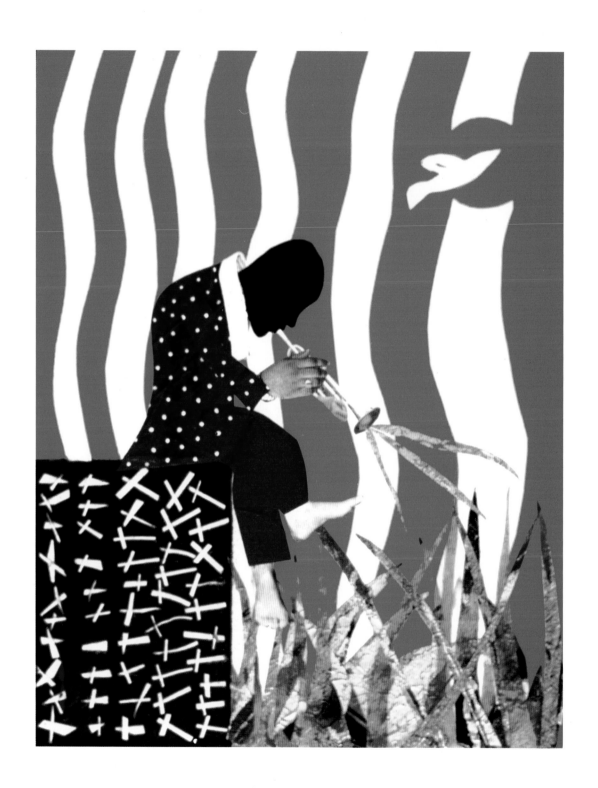

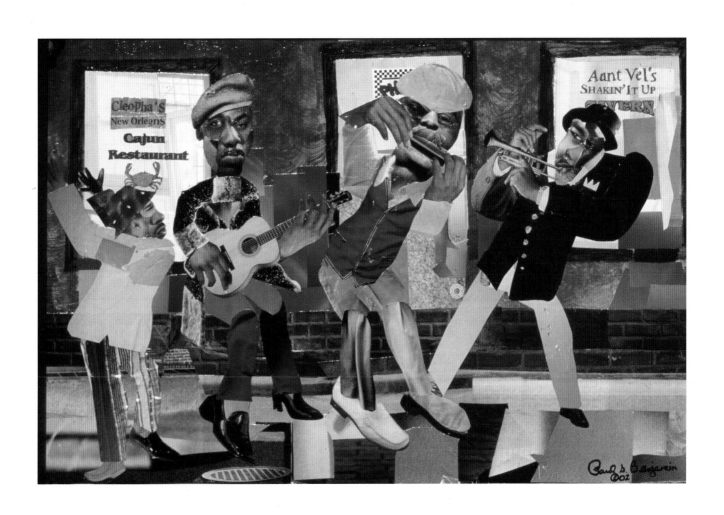

107 Paul S. Benjamin

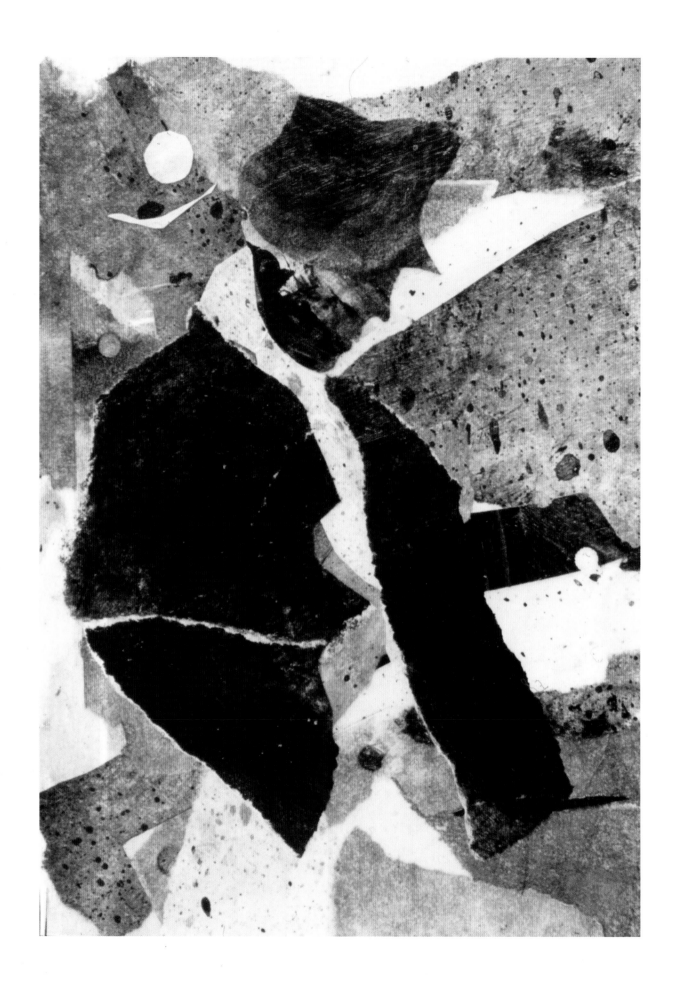

Paul S. Benjamin 108

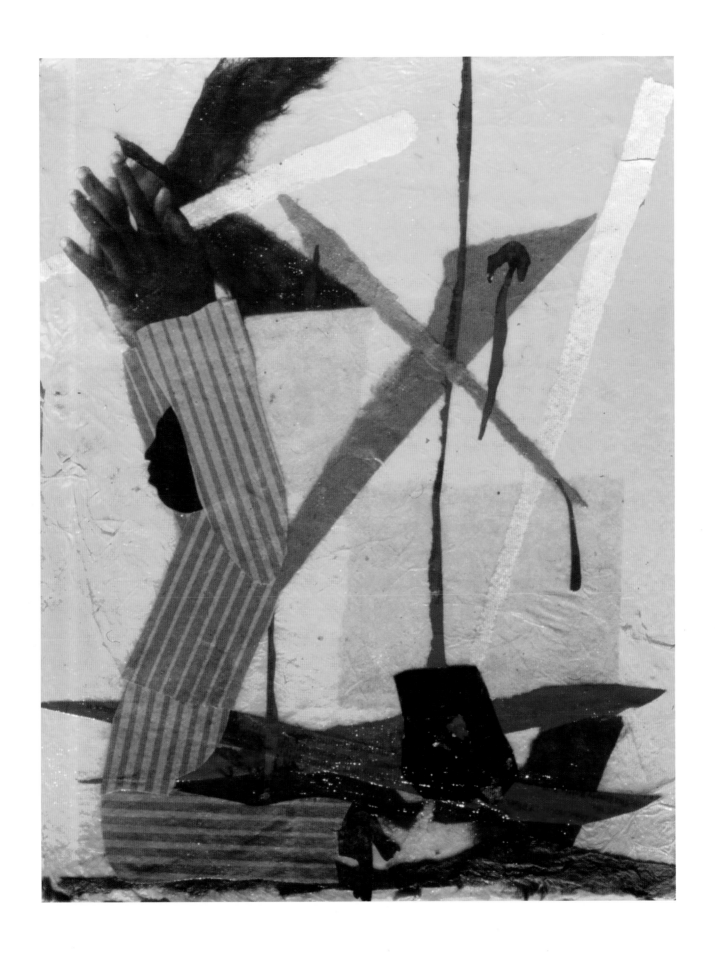

109 Paul S. Benjamin

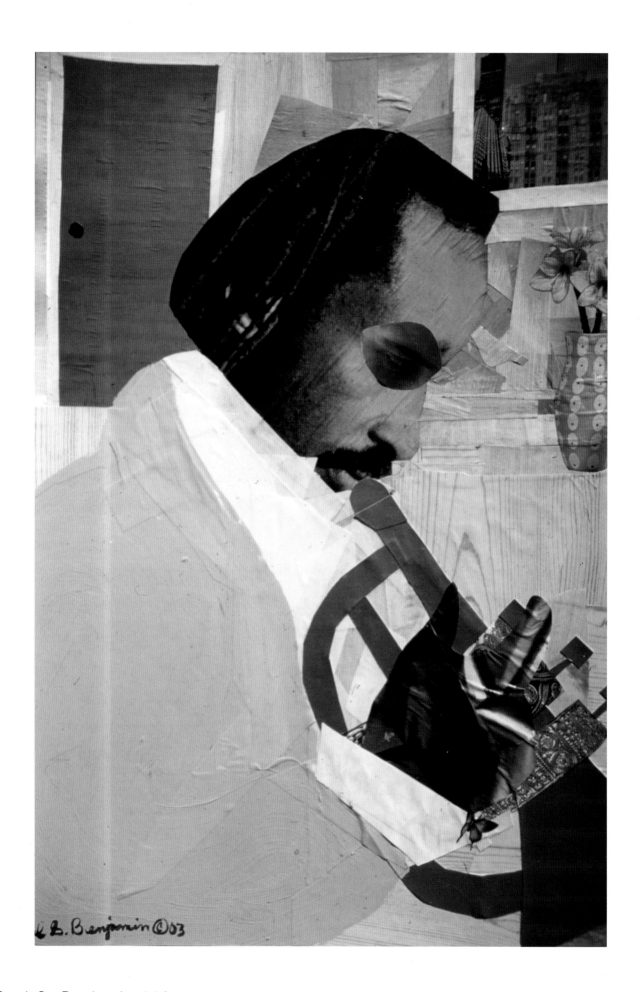

Paul S. Benjamin 110

111 Paul S. Benjamin

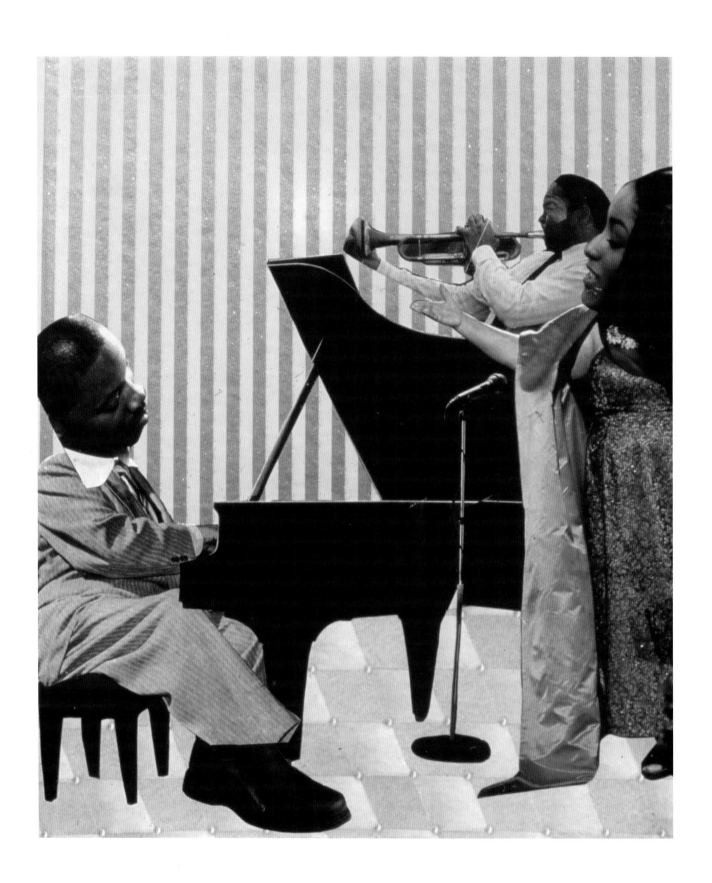

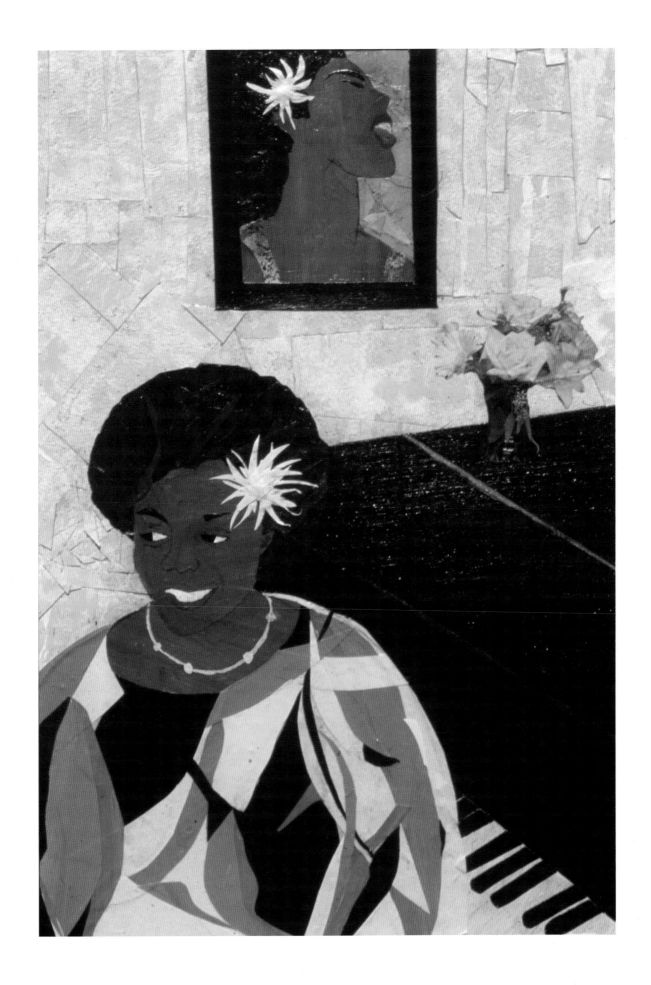

113 Paul S. Benjamin

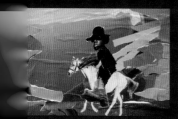

"The Horsemen"
8 1/2" x 11" / Collage

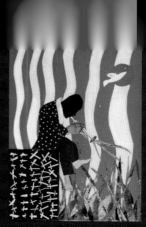

"Fluid Jazz"
30" x 22" / Acrylic on Paper

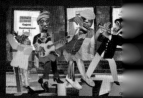

"Trumpet Blast"
10"x8" / Collage

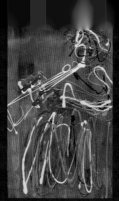

"Street Blues"
10"x8" / Collage

"The Thinker"
7"x5" / Collage

"The Traveler #1"
10"X8" / Collage

"Practice Session"
20"x16" / Collage

"The Band"
30"x22" / Acylic on Pap

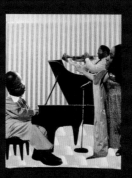

"Standing Ovation"
10"x8" / Collage

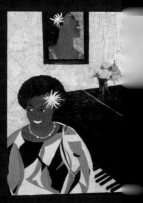

"My Favorite Flowers"
20"x16" / Collage

"Art is an important expression of life that documents t
thoughts and experiences of an individual. The artist invit
people to agree or disagree with their perspective. Howev
one views the art, their outlook on life will determine t
meaning and significance as it relates to their person
experiences and ideologies."

Paul S. Benjamin

Date of Birth: September 6, 1966
Education: University of Illinois, BA

Today I collect for the sheer joy that art collecting brings to my life. I collect because I've come to realize that African American Artists help to keep our amazing culture alive as no one else can. Each and every piece in my collection is of special significance to me. For these reasons, I challenge everyone to embark on this same journey: collect and support African American Artists.

Ricardo Thompson, Art Collector

Verna Hart

A grand narrative pulses through Verna Hart's paintings. She is a griot whose characters live for their music. Her chronicles pace the path of a song, and she always is on the cusp of exactly where the melody gives way to solos about to burst forth from horns or keyboards. Her rich palette also is revelatory in that she steps aside from naturalism to offer up a worldview that is striking on its own terms. Variant shades of a single color are visual syncopations and harmonies, her muse as clear and quick as a run by Dizzy, thirsty after all those salt peanuts.

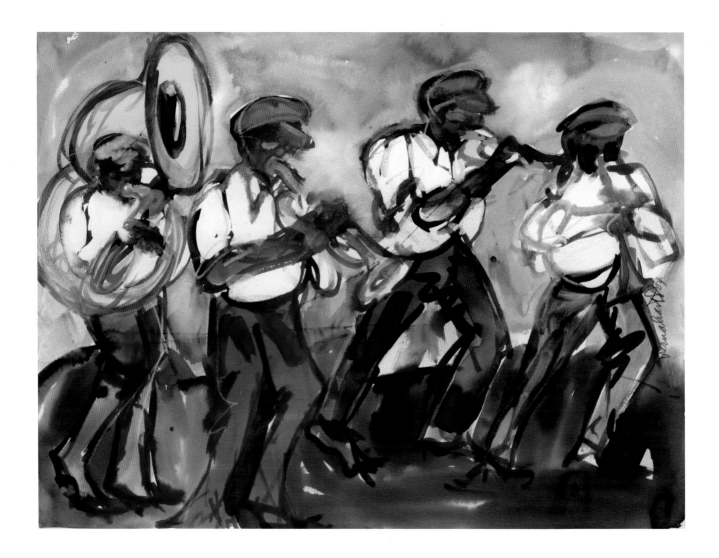

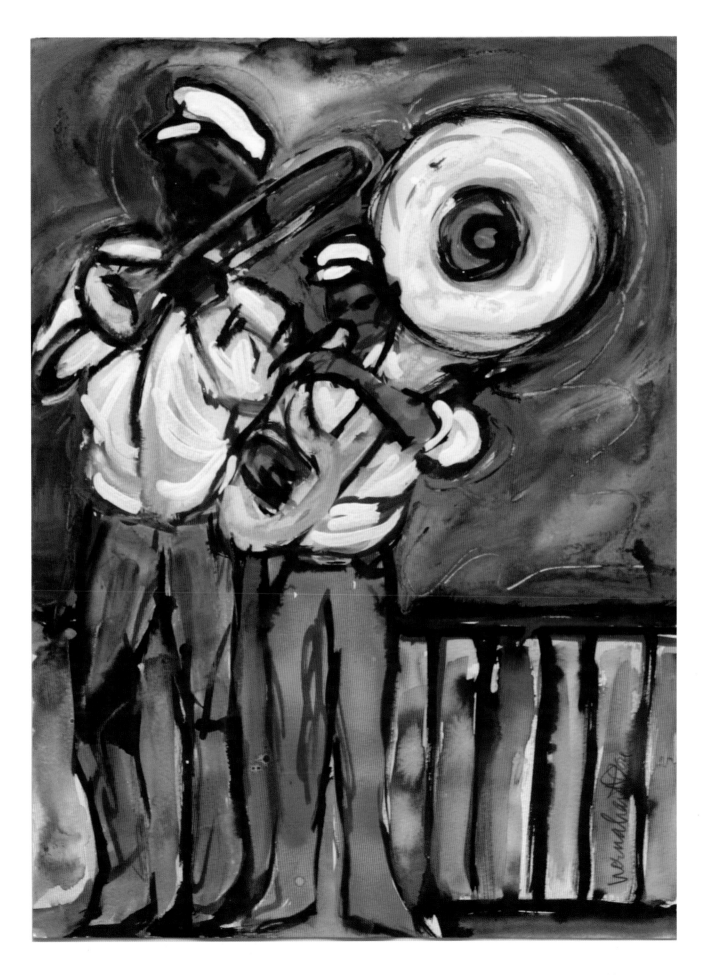

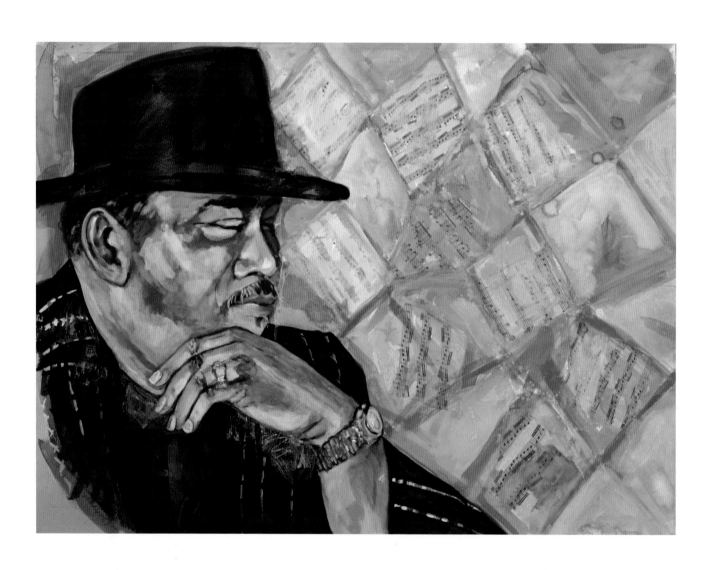

118 Verna Hart

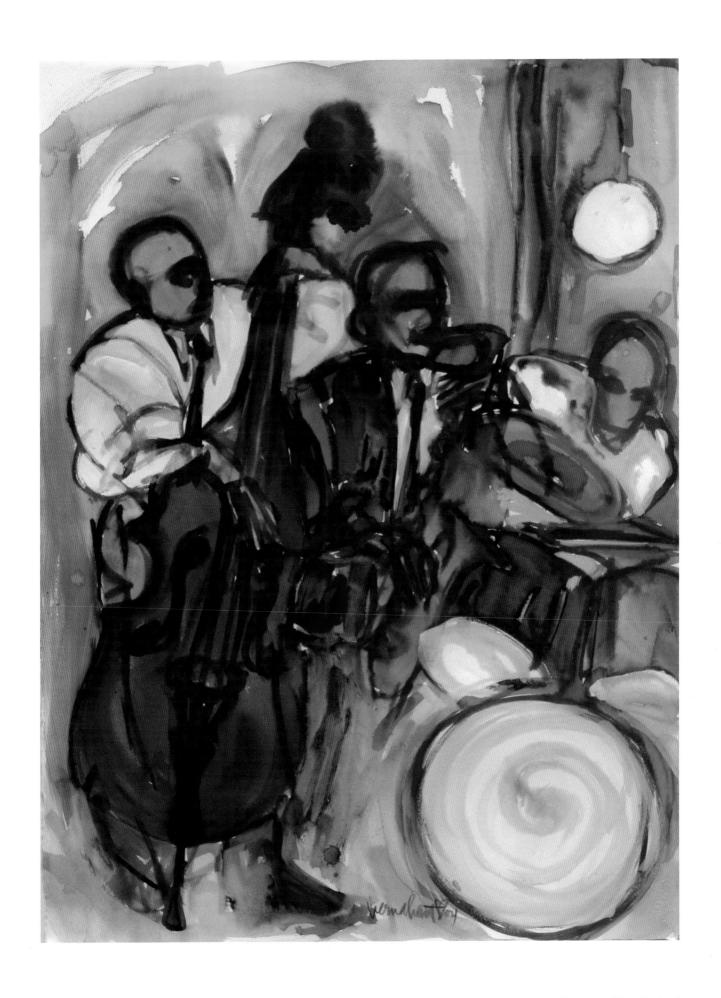

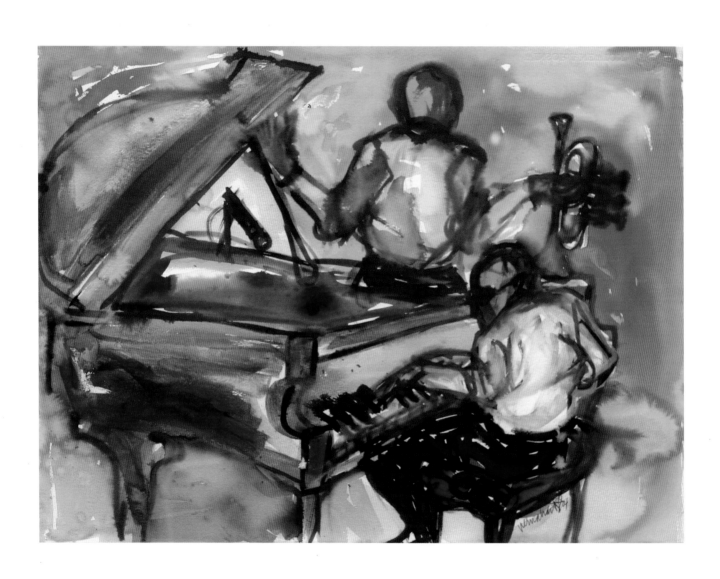

120 Verna Hart

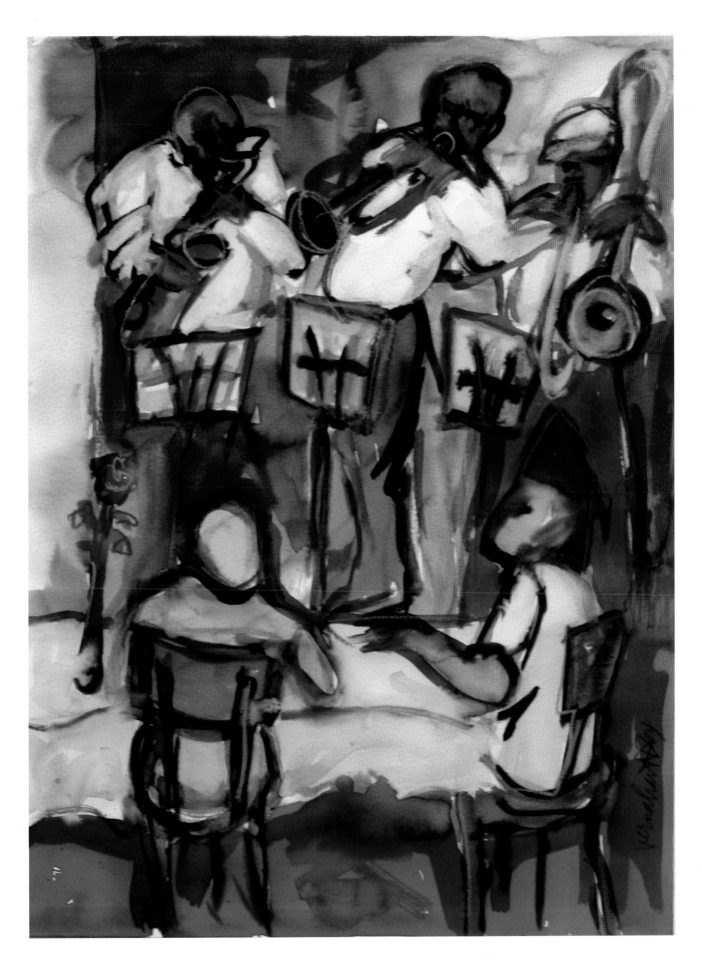

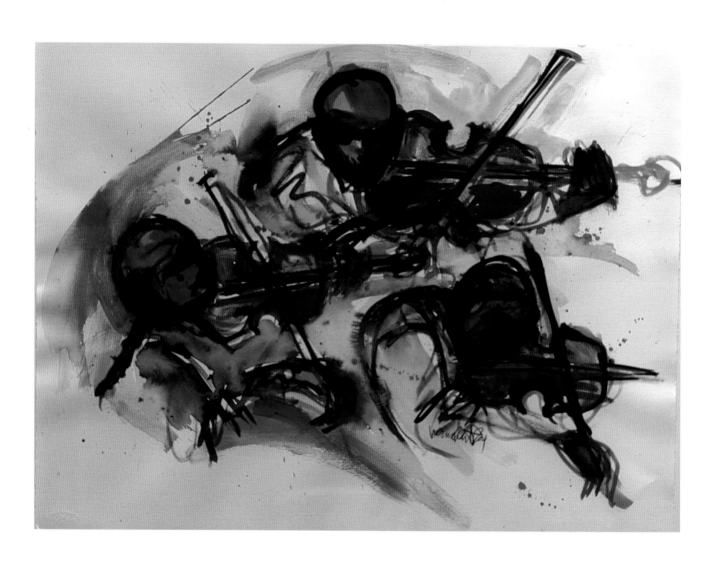

122 Verna Hart

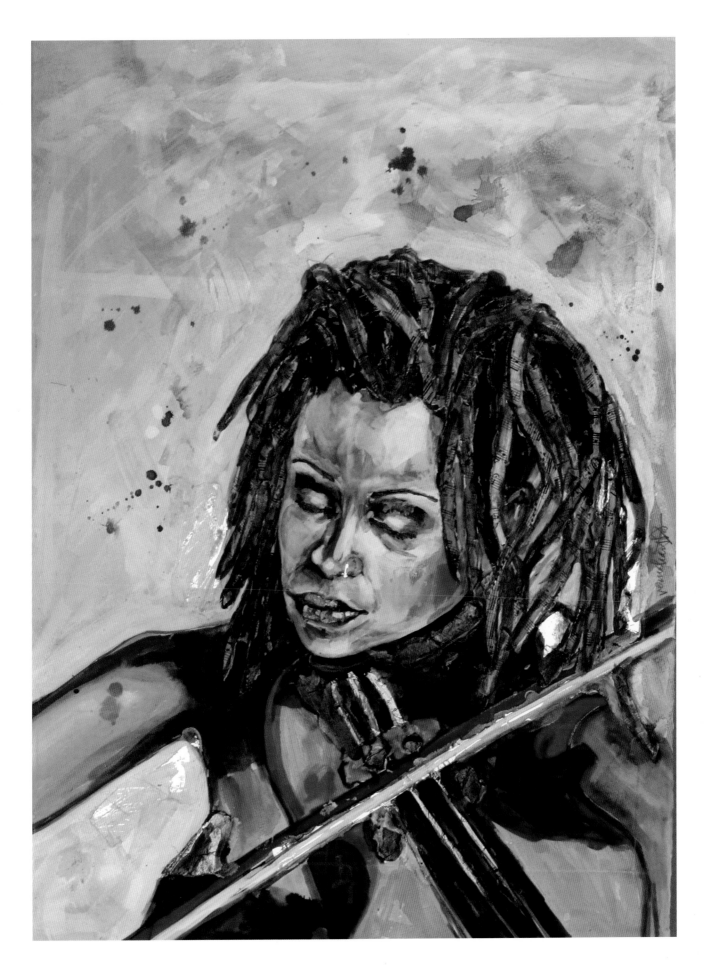

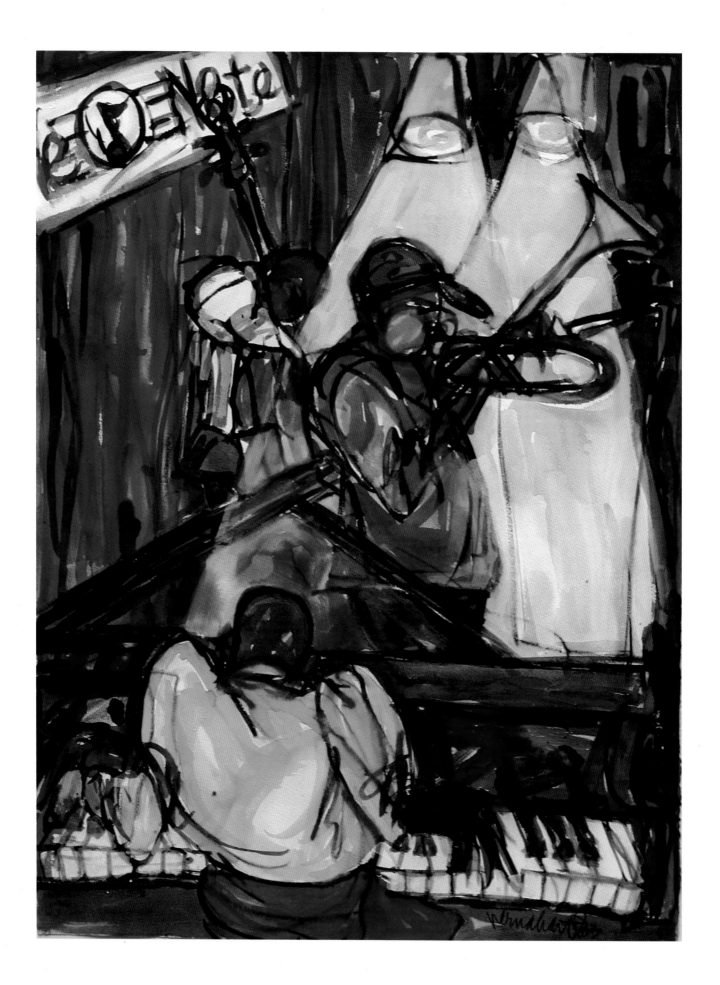

124 Verna Hart

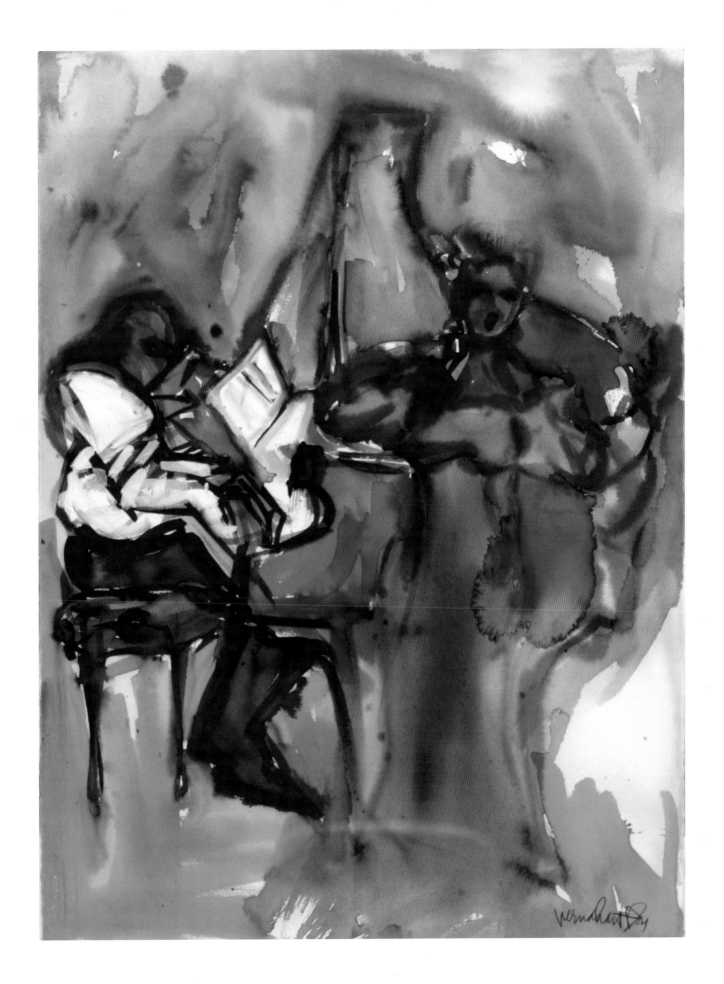

Verna Hart 125

"Oh When da Saints"
15" x 20" / Watercolor

"Tuba Blues"
15" x 20" / Mixed Media

"Phil Perry"
22" x 30" / Mixed Media

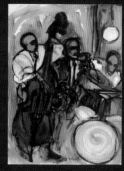

"Saxophone Serenade"
22" x 30" / Watercolor

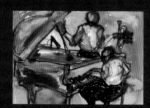

"Trumpeter's Solo"
22" x 30" / Watercolor

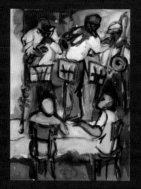

"Brass Trio"
15" x 20" / Watercolor

"Blues for Noel"
22" x 30" / Watercolor

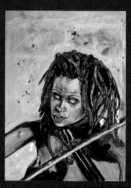

"Regina!"
22" x 30" / Mixed Media

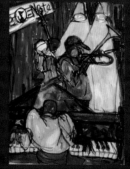

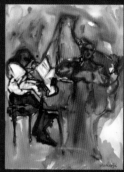

"Once Upon a Blue Note!"
22" x 30" / Watercolor

"Carmen's Solo"
22" x 30" / Watercolor

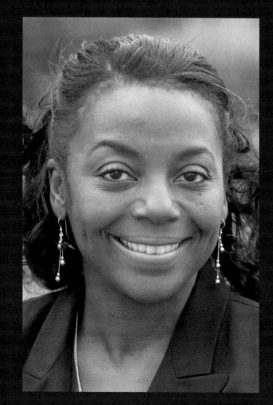

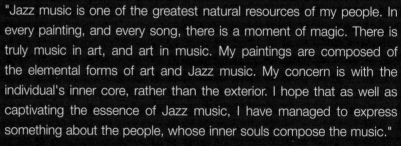

"Jazz music is one of the greatest natural resources of my people. In every painting, and every song, there is a moment of magic. There is truly music in art, and art in music. My paintings are composed of the elemental forms of art and Jazz music. My concern is with the individual's inner core, rather than the exterior. I hope that as well as captivating the essence of Jazz music, I have managed to express something about the people, whose inner souls compose the music."

Verna Hart

Date of Birth: January 28th 1961 • Place of Birth: Harlem, New York
Education: (Bachelor of Fine Art / Painting: School of Visual Arts, New York, New York) Master of Fine Art / Painting: Pratt Institute, New York, New York) (Master of Science in Education: Bank Street College of Education / Parsons School of Design, New York, New York)

Acknowledgements:

God, Mom & Dad, Gerald, Myra & Linda, Audrey, Will Jr., Siobhan, Aja, Pam & Beverly (ArtJaz Gallery), Al Turner, Dyana Williams, Kyle Newport, Tarin Fuller, Fred Hammond, Kirk Quako, Hollis King, Kwaku Alston, Carol Friedman, John Boyd, Rex & Joi Rideout, Ronnie Garrett, Village Camera (Carl), Verve/GRP Records.

I'd like to Thank everyone who graciously allowed me to photograph them for this dream project. I also would like to thank and congratulate all the artists that participated in this first *"UNVEILED"* series. Your work in my eyes is brilliant and I see an amazing future for you all.

Will Downing

ArtJaz Gallery wishes to acknowledge: God in his infinite wisdom to keep us on the right path; our clients that have supported us and our artists through investing in their artwork, thank you; our families for your unwavering support; to our gallery artists, thank you for giving us the chance to represent you and your work and special thanks to Will Downing, Dyana Williams, Paul R. Jones, Alfred Turner, Jr., James Hawes III, Dr. James Steven Blake, Nikki Greene, R.B. Strauss, Harry A. Brown Jr. and Nate Clark. And special thanks to each person that sees the talent and beauty of the art and artists in *"Unveiled."*

Pamela Brown and Beverly Dawson
ArtJaz Gallery